Postcard History Series

Rosendale

POSTCARD HISTORY SERIES

Rosendale

Gilberto Villahermosa

ARCADIA
PUBLISHING

Published by Arcadia Publishing
Charleston, South Carolina

Printed in the United States of America

Library of Congress Control Number: 2018968066

For all general information contact Arcadia Publishing at:
Telephone 843-853-2070
Fax 843-853-0044
E-mail sales@arcadiapublishing.com
For customer service and orders:
Toll-Free 1-888-313-2665

Visit us on the Internet at www.arcadiapublishing.com

To Aaron and Everett,
who fill our lives and the mountain
with joy and happiness

CONTENTS

ACKNOWLEDGMENTS

It truly takes a village to write a book like this. Thankfully, Rosendale is filled with knowledgeable and helpful people who assisted me every step of the way. The idea for this book grew from a conversation with Bill Brooks, town barber, while sitting in his barbershop discussing Rosendale history. Bill, who is also the Rosendale town historian, provided me with historical photographs and information and was always there to answer any question. Linda Tantillo, Rosendale research librarian and an expert on tourism in Rosendale in the 1930s and 1940s, proved an indefatigable researcher and supporter. An avid collector and archivist of Rosendale documents, articles, and images, she supplied numerous photographs, postcards, and material on all aspects of the town's history and responded immediately and enthusiastically to all my requests for information. Althea Werner and John Hogan, of the Century House Historical Society, gave me unlimited access to the society's archives, contributed numerous historical images, and allowed me to photograph freely in the museum and on the Snyder Estate. Michael Ruger, proprietor of the 1850 House, graciously shared his considerable collection of remarkable photos. Vivian Wadlin, editor-in-chief of *About Town*, kindly lent me her sizeable collection of antique Rosendale postcards and allowed me to use many for this book. Carol Johnson, collections coordinator for the Elting Memorial Library's Haviland-Heidgerd Historical Collection in New Paltz, and Margaret Stanne, collections assistant, aided me in selecting and scanning images from the collection and promptly responded to all my inquiries. James Jerkowski, proprietor of the Postage Inn in Tillson, shared historical Tillson photographs with background information. Rachel Myer, of the Women's Studio Workshop in Binnewater, sent me a copy of Francis Marion Platt's *A History of Binnewater in the Cement Mining Times*. Victoria Villahermosa, my daughter-in-law, was my expert on Tillson, where she has lived most of her life. A Krom on her mother's side and thus related to one of Rosendale's founding fathers, Victoria was instrumental in identifying the exact location of many postcards. I also wish to thank my editor at Arcadia Publishing, Angel Hisnanick, for her expert guidance and support, and David Mandel, director of production, for his attention to detail and willingness to incorporate last-minute changes.

Finally, and most importantly, I would like to thank my wise and wonderful wife, Natalie, who grew up in this amazing town. Her support and encouragement, not to mention time spent proofreading and editing, has been incredible. I am blessed to have her by my side.

GUIDE TO IMAGE SOURCES

Century House Historical Society	CHHS
Haviland-Heidgerd Historical Collection	HHHC
James Jerkowski (the Postage Inn)	JJ
J. H. Beers & Company	JHBC
Library of Congress	LoC
New York Public Library Digital Collection	NYPLDC
Rosendale Library	RL
Rosendale Town Historian	RTH
The 1850 House	1850H
Gilberto Villahermosa	GV
Vivian Yess Wadlin	VW

INTRODUCTION

On April 26, 2019, the Township of Rosendale celebrated 175 years since its incorporation in 1844. The name "Rosendale" was once nationally and internationally known, with its natural cement placing it on the map of major American industries in the 19th and 20th centuries.

Rosendale cement built the Delaware & Hudson Canal, which in turn ensured its distribution to markets in New York City and all around the United States. Rosendale cement also built many of the most iconic buildings in New York State and America, including the pedestal of the Statue of Liberty, the Brooklyn Bridge, the wings of the Capitol, and the US Treasury Building. The D&H Canal and the Wallkill Valley Railroad ran through Rosendale, with the latter best symbolized by the towering railroad bridge, initially a wood and iron—and later, steel—wonder in its day. It still looms over the village.

Following the decline of the cement industry and the D&H Canal in the early 1900s, Rosendale embarked on an ambitious program to bring vacationers to its many boardinghouses and hotels to enjoy the region's natural setting year-round. That program was best exemplified by the tagline "Vacationist Rendezvous," with booklets printed and license plates manufactured to market tourism in the 1930s and 1940s. Construction of the New York State Thruway in the mid-1950s ended Rosendale's run as a tourist destination. Ironically, the Thruway also was built of Rosendale natural cement.

Rosendale was, in October 1872, one of the most enterprising little villages in Ulster County, according to its residents. "A stroll through its pleasant quiet streets will fairly corroborate this fact," reported the *New Paltz Independent*.

"We have stores and shops stocked with goods indispensable and beautiful, show-windows arrayed in attractive fabrics and colors, and the number of buildings at present undergoing erection, to be occupied also in the capacity of mercantile and manufacturers, affirm, in a measure, the unprecedented prosperous growth of our village. Our schools and churches are conducted in proper order and with distinct manifestation of utility. Our village can boast of its numerous pleasant hotels and their hospitable and accommodating landlords. The grand Rondout flows in close proximity to the village, and its limpid waters are plainly perceptible from our windows and streets."

Today, almost 150 years later, it retains much the same atmosphere. Rosendale is the best that small-town America has to offer. Visitors can expect a warm welcome, along with great food and drink, quality music, comfortable accommodations, and good company wherever they turn. The Wallkill River and Rondout Creek beckon kayakers and canoers; the mountains, hikers and rock climbers; the Wallkill Rail Trail (a 24-mile linear park), joggers and bicyclists; and the caves, intrepid explorers. The village's epic street festival, as well as the Frozendale winter festival, Pickle Festival, and Zombie Festival attract tens of thousands of visitors every year, as do the many farmers' and flea markets. Rosendale has many historic buildings—the Old Dutch Church, the Episcopal Church and St. Peter's Church; the Rosendale Café, the Rosendale Theater, the 1850 House, and the Red Brick Tavern, to name a few. Towering over the town is the Rosendale Trestle, an impressive pedestrian walkway 150-feet above Rondout Creek. These structures, along with the empty cement caves and kilns, all harken back to the late 19th and early 20th centuries when little Rosendale was an industrial powerhouse set in the midst of paradise.

One

ROSENDALE VILLAGE

Situated in the scenic Rondout Valley, formed by the Catskill and Shawangunk Mountains, the town of Rosendale is located immediately west of the town of Esopus. The two are separated by the Wallkill River and Rondout Creek. Rosendale is bordered on the south by New Paltz, on the west by Marbletown, and on the north by Hurley. The area consists of rolling and broken upland, with the highest summits being 200 to 500 feet above the valleys. The soil is chiefly a sandy loam. In the southwest are three caves in a ledge of rocks of the Shawangunk Mountains, where ice is formed throughout the year. Cement was once extensively manufactured throughout the town. At one point, the Wallkill Valley Railroad extended the length of the town.

Rosendale was formed by an act of General Assembly on April 26, 1844, from parts of the towns of Marbletown, New Paltz, and Hurley. New York State officials believed it was necessary to place the booming cement industry under the control of a single political and geographical entity. Among the town fathers were Abraham Auchmoody, Andrew De Bois, Abraham Coutant, Christian Deits, Cornelius Delemeter, Moses Keator, Jacob Rutsen, Jacob Snyder, John Sammons, and Cornelius Sluyter. Col. Jacob Rutzen, one of the richest and most powerful men of Dutch descent in America, was also one of the founding fathers of Esopus and Hurley. He came to Rosendale from Albany and on October 8, 1677, purchased a tract of land "in a place called Rosendale" along the Old Indian Trail that connected the Hudson Valley with the headwaters of the Delaware River and at the place where the Trail crossed the Kings Highway. Rutzen occupied one of the first stone houses in the village, giving Rosendale its name. Cornelius LeFevre was from New Paltz. Charles Dewitt, whose family had resided in the area since 1736, was a member of the Provincial Congress when it met at Kingston.

The name "Rosendale" derives from the Dutch term for "rose valley," which appears in a 1685 document for land on Rondout Creek. The first settlement of Rosendale, by the Dutch, took place in about 1700. An inn, the Rosendale Farm, was kept there in 1711. This same stone house served as the office of the loan commissioner of Ulster County. Gen. George Washington, his wife, Martha Washington, New York governor George Clinton, and his wife, Sarah, were entertained in the house by Col. Johannes Hardenberg, one of Washington's staff officers, in June 1783.

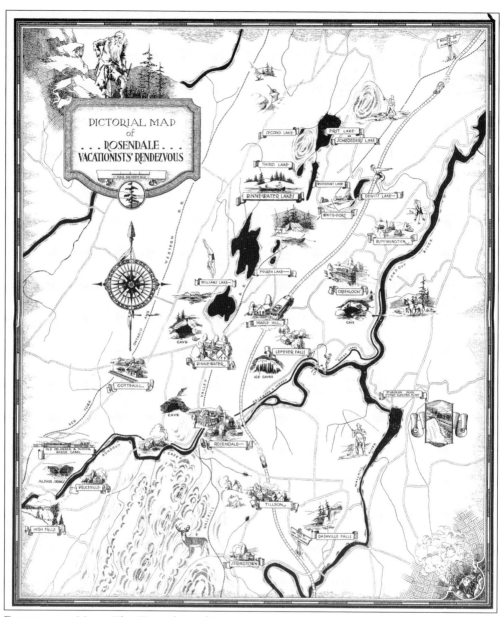

ROSENDALE MAP. The Township of Rosendale includes the communities and hamlets of Binnewater, Bloomington, Bruceville, Cottekill, Creek Locks, Hickory Bush, Kallops Corners, Lawrenceville, LeFever Falls, Maple Hill, Rosendale Village, Tillson, and Whiteport. Only a small section of High Falls is part of Rosendale; the majority belongs to Marbletown and Rochester. Rosendale also includes the firehouses of Binnewater, Cottekill, and Tillson. This map, produced by the Rosendale Town Association in the 1930s, shows all points of interest in and around Rosendale. (RL.)

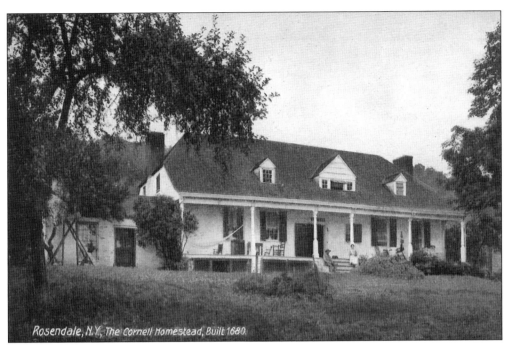

Rosendale, N.Y., The Cornell Homestead, Built 1680.

THE CORNELL HOMESTEAD. The Hudson Valley's Ulster County was settled by the Dutch in the mid-1600s. Built by Direck Keyser, this building was one of the earliest stone houses in the region and the first in Rosendale. Keyser lived and labored for 20 years here until Col. Jacob Rutsen, then 50 years old, took possession of the property in 1700. Incorporating the original house into the new building, Rutsen erected a stone mansion 62 by 25 feet facing the King's Highway. (GV.)

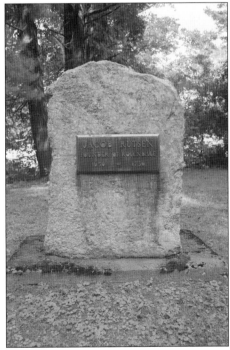

GRAVE OF COL. JACOB RUTSEN. Jacob Rutsen is considered the founder of Rosendale and Esopus and one of the founding fathers of Hurley. Born in New York in 1650, he came to Kingston, New York, in 1678 and began buying choice parcels of land from the Indians. By his old age, he possessed a large estate and was the wealthiest man in the area. Rutsen was a member of the General Assembly four times. He was also a justice of the peace, judge of the Court of Common Pleas, and an officer of Ulster & Dutchess County Troops, retiring in 1728 as a colonel. Rutsen died in 1730. He is buried in the small Rosendale Cemetery off Central Avenue behind the Rosendale Library. (GV.)

11

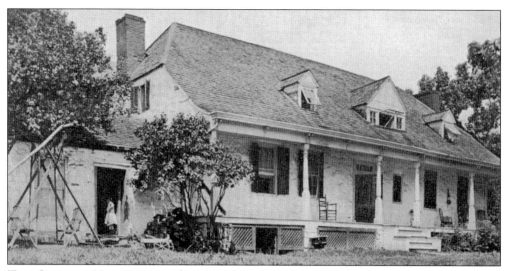

THE CORNELL HOMESTEAD. This is another view of the Cornell Homestead, also called the Rutsen House and the Hardenberg House, once located behind today's Rosendale Library. On November 17, 1782, General Washington and his military staff, traveling from Port Jervis to Kingston, took dinner with Colonel Hardenbergh at the Rutsen House. When it burned down in 1911 after a lightning strike, the house was owned by Maj. Thomas Cornell. Much of the masonry was thereafter hauled away to Kingston and incorporated into a building erected by the Coykendall family. (GV.)

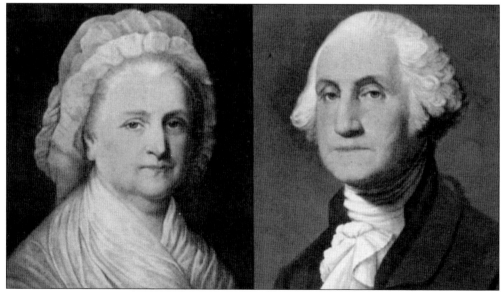

GEORGE AND MARTHA WASHINGTON. George Washington and his wife, Martha, visited Rosendale several times. The town's location on the King's Highway south of Kingston made it a convenient stopping point for America's first President and his spouse during and after the Revolutionary War as they traveled throughout the area. Jacob I. Signor of High Falls owned an old-fashioned mahogany bedstead that General Washington reportedly slept in one night during the Revolution. The *New Paltz Times* reported, in December 1877, that the bed had "the same curtains that hung around it when Washington snored and dreamed of Burgoyne and his army within its hospitable embraces." (GV.)

MARTHA WASHINGTON'S VISIT TO ROSENDALE. On June 20, 1783, Richard Varick wrote a letter to Colonel Hardenbergh expressing Martha Washington's wish to breakfast with the colonel and his wife at their Rosendale home the following morning. Traveling from Kingston to Newburgh, Martha was accompanied by Gov. George Clinton and his wife, Sarah, along with General Washington's devoted friend and companion-in-arms, Varick. (RTH.)

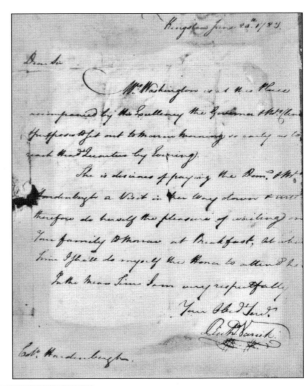

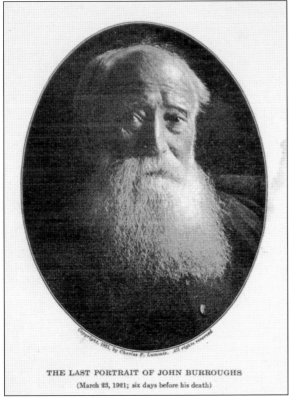

THE LAST PORTRAIT OF JOHN BURROUGHS
(March 23, 1921; six days before his death)

THE LAST PORTRAIT OF JOHN BURROUGHS. John Burroughs, a well-known American naturalist and nature essayist active in the US conservation movement, was a Rosendale school district teacher in the 1850s. Best known for his observations on birds, flowers and rural scenes, he counted among his friends and acquaintances such notables as Thomas Edison, Henry Ford, Walt Whitman, and Theodore Roosevelt. Born and raised on a family farm in the Catskill Mountains, Burroughs later owned a farm in Esopus, near Rosendale. From 1854 to 1856, he alternated periods of teaching with periods of study at higher education institutions. (CHHS.)

13

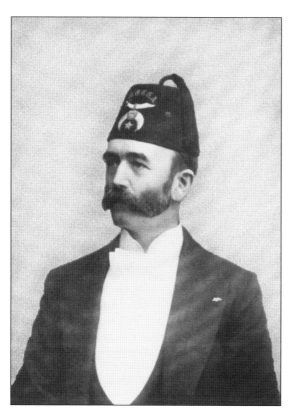

RUFUS SNYDER, 1896. A popular Rosendale merchant and proprietor of the leading hardware store on Main Street, Rufus Snyder was born in the township on May 23, 1845. His father, William Henry Snyder, also born in Rosendale, was classed among the pioneer merchants of Ulster County. The younger Snyder was an agent for the Wallkill Valley Rail Road before embarking on the hardware business. He opened a hardware store on Main Street in the 1870s and operated it for 30 years. It was later purchased by Silas Auchmoedy, who worked in the store. Rufus's wife, Mary, ran a flower conservatory next door. (JHBC.)

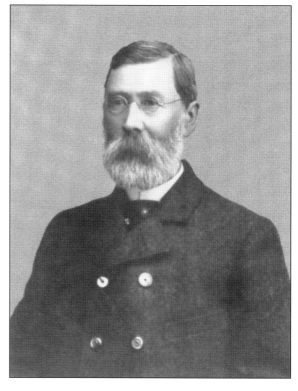

DANIEL A. BARNHART, 1896. Born on December 9, 1843, in High Falls, Daniel Barnhart was one of Rosendale's prominent businessmen. A Civil War veteran of New York's 20th Infantry Regiment, Barnhart fought at Fredericksburg and Gettysburg, where he was taken prisoner. After the war, he was the foreman of a cooperage in High Falls, which produced barrels for the transport of Rosendale cement. Successful in this endeavor, he relocated to East Kingston, where he took charge of the Hudson River Cement Works and, later, the T.R. Keator & Company Cement Works. (JHBC.)

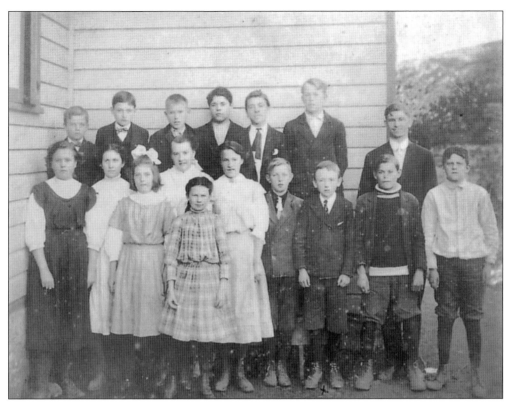

ROSENDALE SCHOOL STUDENTS. In March 1880, Rosendale had a population of 3,625. Its seven school districts employed nine teachers. Although some 1,250 children were of school age, only 775 were enrolled with 350 attending regularly. The one-room schoolhouse was the norm in rural areas, with some children walking up to four or five miles to attend. The school year was 132 days long. Schools in the late 19th century were, for too many, joyless places of corporal punishment and mind-numbing rote memorization. (CHHS.)

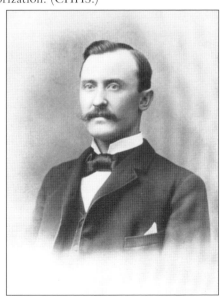

HARVEY CLEMENT KEATOR, MD. Born in Rosendale township in 1860, Harvey Clement Keator grew up in Rosendale and worked at Jacob A. Snyder's store in the village for three years. He graduated from Long Island College Hospital in 1891 and returned to Rosendale, where he built up a large and lucrative practice as a doctor. Rural doctors in New York State, like Keator, would have charged 50¢ for an office visit or a house call, $2 to $10 to treat a bone fracture, and $4 for labor and delivery. Rosendale had three or four doctors by the late 1800s. (JHBC.)

LIBERTY STAGECOACH IN UPTOWN KINGSTON, 1918. Two stagecoach companies ran regularly between Rosendale and Kingston in the 1870s. The cost was $1. In October 1872, each company tried to put the other out of business. "A few days ago, Sammons put on a stage and offered to take the passengers to Kingston for 75 cents," reported the *New Paltz Independent.* "Lasher thereupon said he would carry them for 50 cents. Sammons offered to do it for 25 cents. Lasher said he would carry them for nothing, and Sammons offered them a quarter to go with him. Thereupon, ten of the passengers who had come with the [rail] cars got into Sammon's stage and three into Lasher's." (GV.)

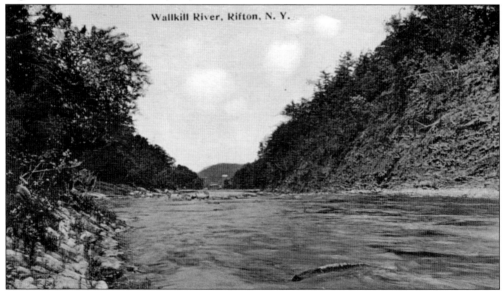

WALLKILL RIVER, RIFTON, NEW YORK, EARLY 1900S. The Wallkill is another reason the Hudson Valley remains a favorite for lovers of nature and the outdoors. A tributary of the Hudson River, it flows generally northeasterly from Lake Mohawk in Sparta, New Jersey, 88.3 miles to Rondout Creek in New York. The Wallkill has the unusual distinction of being a river that drains into a creek, due to being impounded shortly before the Rondout confluence into a small body of water called Sturgeon Pool near Rifton. This card is postmarked July 1, 1910. (GV.)

PERRINE'S BRIDGE. Built in 1844, Perrine's Bridge, which spans the Wallkill River between Rosendale and nearby Rifton on Route 213, is the second oldest covered bridge in New York State. The 138-foot covered wooden bridge is today part of the towns of Rosendale and Esopus. Perrine's Covered Bridge is named for French Huguenot immigrant James W. Perrine, a descendant of Daniel Perrine known as "the Huguenot," who owned a tavern/hotel near the bridge site. The bridge has been repaired numerous times throughout its existence. (GV.)

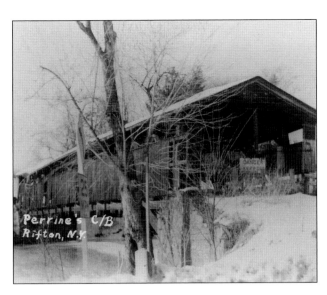

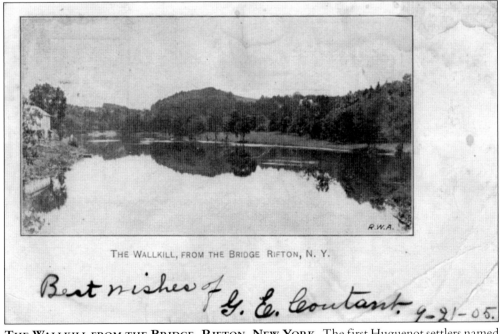

THE WALLKILL, FROM THE BRIDGE RIFTON, N. Y.

THE WALLKILL FROM THE BRIDGE, RIFTON, NEW YORK. The first Huguenot settlers named this waterway the Pfalz River, after Die Pfalz, their first refuge in Germany. Later, when it was clear that the river continued well beyond the original New Paltz patent, it was renamed after the Waal River in the Netherlands. Vacationers frequented the Wallkill from the late 19th to the early 20th century for recreation. In 1955, the river experienced record flooding when August Hurricanes Connie and Diane and October storms brought unprecedented rainfall to the region. This card is postmarked September 24, 1909. (GV.)

LOOKING NORTH ON RONDOUT CREEK, EARLY 1900S. Rondout Creek is a 63-mile long tributary of the Hudson River running through Ulster and Sullivan counties in New York state. It parallels Rosendale's Main Street on the south. The Rondout was important economically during the 19th century when the Delaware & Hudson Canal paralleled it from Napanoch, in the west, to Rondout (now part of Kingston) in the north. This card is postmarked August 27, 1915. (GV.)

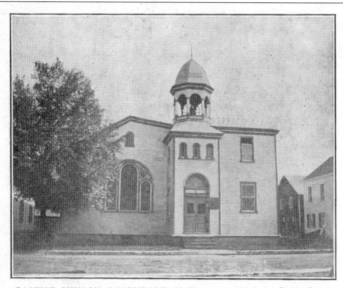

BAPTIST CHURCH, ROSENDALE, N. Y. Pub. by C. Veeder.

BAPTIST CHURCH. Incorporated on May 22, 1840, the Baptist parish in Rosendale was the oldest in Rosendale Village. The church was built in 1842 on a lot donated by Jacob A. Snyder. A great revival, in the winter of 1875–1876, brought in many new members. By January 1883, however, the *New Paltz Times* reported that the village of Rosendale was without a single Protestant pastor—the Baptist and Reformed churches having been without one for some time and the Episcopal rector having departed in December 1882. The situation was later remedied. The Baptist church building later became the Rosendale Grange. The card is postmarked 1909. (GV.)

ROSENDALE REFORMED CHURCH, EARLY 1900S. Another of Rosendale's oldest and most iconic buildings, the parish of the Old Dutch Reformed Church was incorporated on November 28, 1843. Reverend J. McFarland was the first pastor. Erected in 1843, the original church seated 300 and cost $2,500. Rev. M.F. Libeneau headed the church in 1871. His parish consisted of 83 persons. The church burned down and was rebuilt in 1895. In 1985, it was renovated and converted into a glass design and sculpture studio. Today, the Belltower is a unique and welcoming event venue. (GV.)

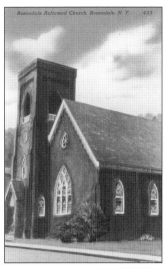

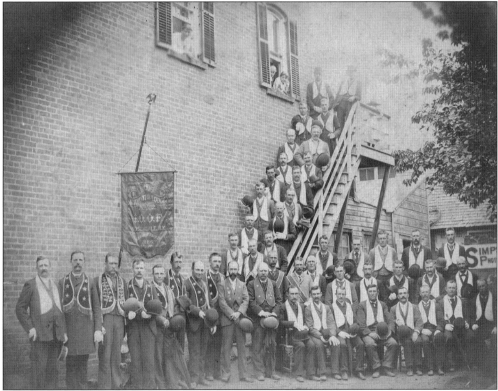

INDEPENDENT ORDER OF ODD FELLOWS HIAWATHA LODGE NO. 532 IN 1886. The Independent Order of Odd Fellows (IOOF) was founded in 1819 by Thomas Wildey in Baltimore, Maryland. The order was also known as the Triple Link Fraternity, referring to the order's "Triple Links" symbol, alluding to its motto "Friendship, Love and Truth." The IOOF became the first fraternity in the United States to include both men and women, on September 20, 1851. Beyond fraternal and recreational activities, the order promoted the ethic of reciprocity and charity. By 1889, the order had lodges in every American state. The Great Depression and FDR's New Deal resulted in a precipitous decline in membership. (1850H.)

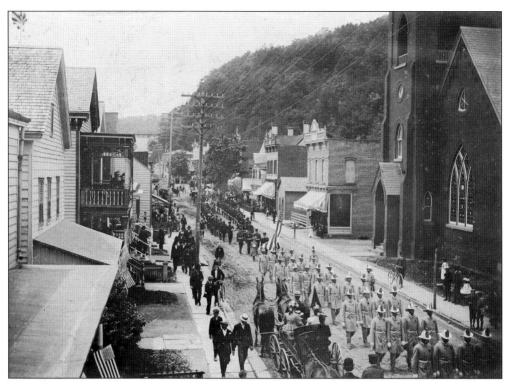

NEW PALTZ FIRE DEPARTMENT MARCHING IN ROSENDALE DECORATION DAY PARADE, 1899. Firemen from all around the region marched in the various holiday parades. Before the end of World War I, Memorial Day was known as Decoration Day. Families, friends, and town folk would visit their local cemeteries and decorate the graves of those soldiers who died in the Civil War with flowers, ribbons, and flags. (HHHC.)

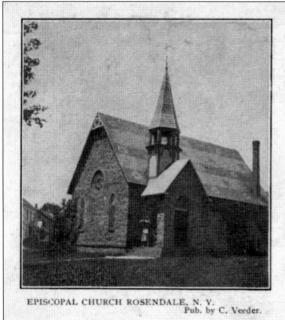

EPISCOPAL CHURCH ROSENDALE, N. Y.
Pub. by C. Veeder.

EPISCOPAL CHURCH ROSENDALE, EARLY 1900S. At its height, the Rosendale cement industry had more than a dozen cement plants and employed 5,000 workers, making the town a rough and rowdy place. Violent brawls between cement miners and railroad workers were common, with the local priest or a reverend called upon to quell the violence. To inspire its workers to do something more wholesome on Sundays than frequent taverns to drink, gamble, and fight, local cement companies promoted the building of churches. Rosendale's Episcopal All Saints' Chapel was built on the northeast end of Main Street in 1876. It seated 150 and cost $2,000. (GV.)

ST. PETER'S CHURCH, EARLY 1900S. St. Peter's Roman Catholic Church is one of the oldest Catholic parishes in the Hudson Valley. It was organized in 1851 by Fr. Martin O'Flaherty with about 50 members. The first services were held under a tree on the present site of the church. The first wooden house of worship was erected in 1852 and seated 350. By 1871, the parish consisted of 1,500 persons, with the property valued at $10,000. The cornerstone for today's St. Peter's Church was laid on September 30, 1875. (GV.)

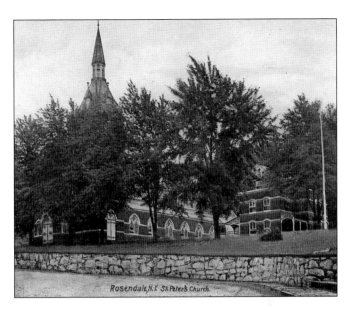

Rosendale, N.Y. St. Peter's Church.

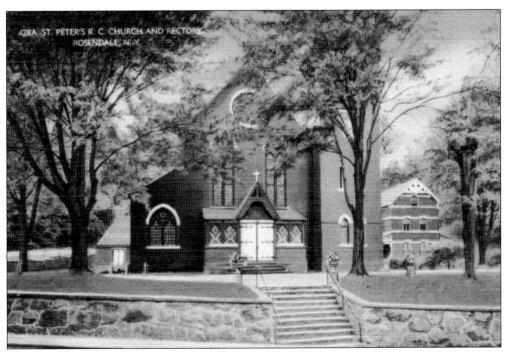

ST. PETER'S CHURCH AND RECTORY, EARLY 1900S. Construction of the church and rectory was completed in 1876. The opening was attended by an immense crowd of 2,000 people, along with brass bands from neighboring High Falls and Rondout. The church was built in the Gothic Revival style popular in the mid-1800s. When completed, the beautiful altar was considered one of the finest in the country. Father O'Flaherty celebrated the first Mass at the new St. Peter's Church on Christmas Day 1876 with 800 worshippers in attendance. The church was gutted by fire in December 1903. It was rebuilt and finished in 1909. (VW.)

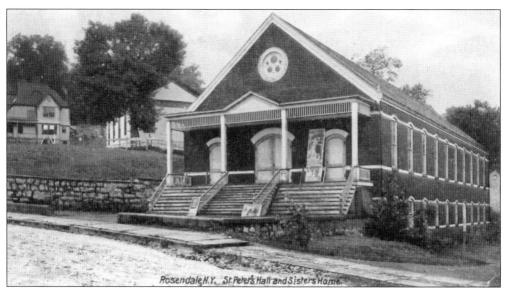

St. Peter's Hall and Sister's Home, Early 1900s. St. Peter's continued to grow, adding a hall and, later, a school. St. Peter's Hall and Sister's Home were completed in 1890. The hall was used for festive gatherings and performances. In the 1930s and 1940s, the Men's Club of Rosendale met there regularly to play shuffleboard, table tennis, dart ball, and other games. St. Peter's hosted an annual St. Patrick's Day Supper, which was attended by as many as 340 people in March 1930 and was followed by dancing. (GV.)

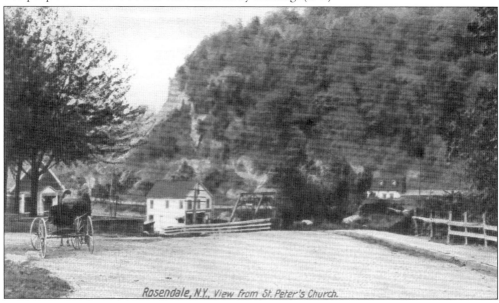

View from St. Peter's Church, Early 1900s. Postmarked 1910, this card shows the view from St. Peter's Church northward toward Joppenbergh Mountain. The bridge across the Rondout was erected in 1879. According to longtime Rosendale resident and *Rosendale News* columnist Joseph Fleming, at least two other bridges preceded it. Documents dated 1818 mention a bridge at this point. The house at the right is the Huben house. Prior to 1800, the creek was forded via nearby shallows. A New York State historical marker marks the fording site today. (VW.)

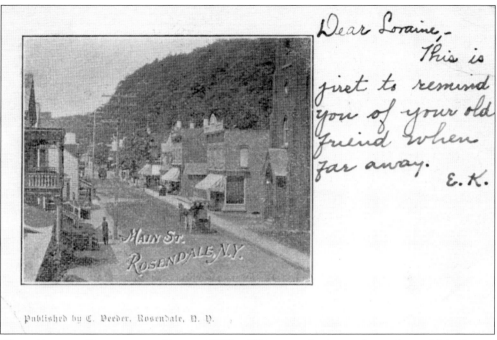

MAIN STREET ROSENDALE, EARLY 1900S. This scene looks southeast down Main Street. Joppenbergh Mountain looms over the town. In 1900, the population was 6,278, with some 5,000 employed in the booming cement industry. The Old Dutch Reformed Church is the first building on the right. In 1893, the village trustees ordered that a flagstone walkway be constructed alongside Main Street. Prior to the 1900s, Rosendale had two photography studios, Whipples and Hunters, which took many fine views of the town. Perhaps this photograph can be attributed to one of them. This card is postmarked November 30, 1905. (GV.)

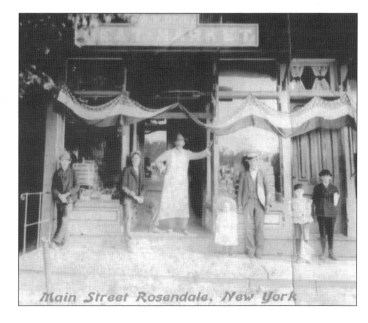

Main Street Rosendale, New York

W.M. DEPUY'S MEAT MARKET, MAIN STREET ROSENDALE, EARLY 1900S. This building is located on the south central portion of Main Street. Before the existence of supermarkets, customers had to visit their local butcher to buy meat. These shops sold not only fresh meat but also hams, bacon, salt meat, canned meats, and lard. The butcher and his family normally lived above the shop. Depuy exchanged his bloody apron for a clean one for this photograph. (1850H.)

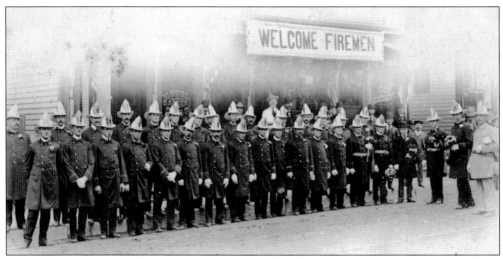

ROSENDALE ACTIVE HOSE COMPANY, 1905. Although fires were frequent in the history of Rosendale, the town's first fire department was not formed until 1895, following one of the worst infernos in the Rosendale's history. The blaze devastated 27 buildings, sweeping a 300-yard strip clean of structures between Main Street and the D&H Canal. The Rosendale Active Hose Company was one of the best-drilled organizations of its type in the area, making a good impression in parades. The abilities of Rosendale's firefighters helped to keep local fire insurance rates low. (RL.)

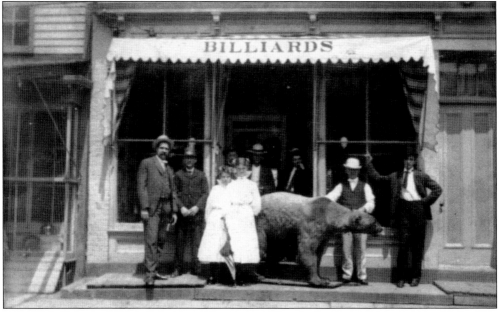

FRANK FLANNIGAN'S BILLIARD HALL. Pictured is another Main Street establishment. In the 19th and early 20th centuries, billiards was a favorite pastime, in towns great and small. The first national billiards championship was held in New York City in 1878. Afterward, pool and billiard championship tournaments were held annually. At times, including during the Civil War, billiard results received wider coverage than war news. Some billiard players were so renowned that cigarette cards were issued featuring them. The proprietor, Frank Flannigan, and his customers are shown here with a stuffed grizzly bear. (1850H.)

HOLIDAY CROWD ON MAIN STREET ROSENDALE, EARLY 1900s. This house, on the north side of Main Street, is adorned for Decoration Day. Main Street would be filled with parades and bands and residents would spend a festive day together. After World War I, Decoration Day came to be known as Memorial Day. (1850H.)

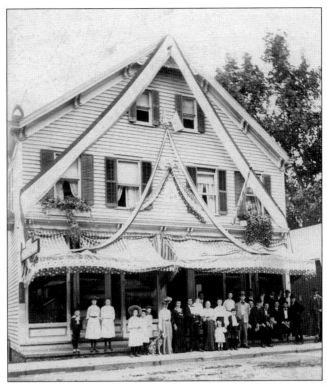

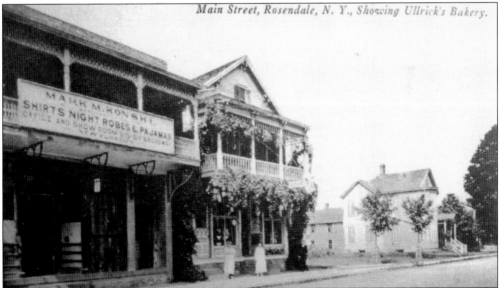

Main Street, Rosendale, N. Y., Showing Ullrick's Bakery.

ULRICK'S BAKERY, 1907. Ulrick's Bakery (previously, Will Sammons' Bakery) is on the right. On the left is the Mark M. Konski factory, which manufactured night robes and pajamas. The firm employed Rosendale women for a decade after opening. It closed near the beginning of World War I in 1914. Efforts to employ men from Rosendale in similar endeavors came to naught, as the townspeople refused to work the long hours for low pay demanded by interested firms. It was during this period that Rosendale's board of trade was formed to improve working conditions. (CHHS.)

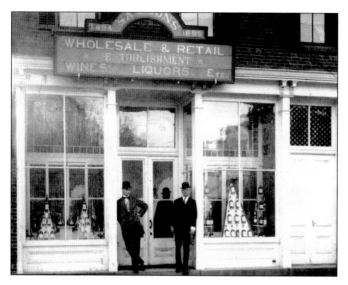

SAMMONS WHOLESALE & RETAIL. Opened in 1854, this building, across the street and to the west on Main Street from Sammons Hotel, was another Sammons property. Later, it became Reid's Hotel, which burned down in 1969. The proprietor was Joseph S. Reid, mayor of Rosendale from 1967–1969. Reid was a leader in the Democratic Party of Rosendale, which had monthly meetings in his hotel. Today, the building to the right is Bill Brook's barbershop. (RTH.)

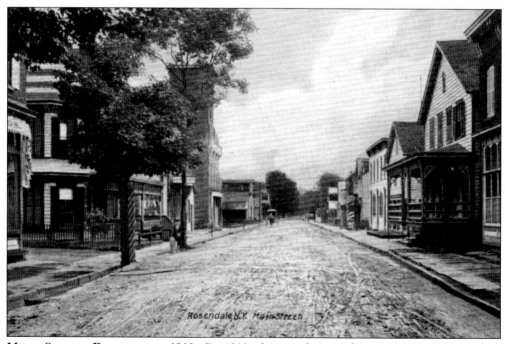

MAIN STREET ROSENDALE, 1910. By 1910, the population of Rosendale had dropped to 3,717, down from 4,670 (of which 4,436 were native-born) only five years earlier. This was due to the decline of both the Rosendale cement industry and the D&H Canal. This scene looks northwest down Main Street. The Old Dutch Reformed Church is the tall redbrick building visible on the left. Note the cobblestone sidewalks and the road lined with paving stones. The center of the road has been paved with cement cinders for strength and durability. (GV.)

EPISCOPAL CHURCH AND LOWER END OF MAIN STREET, 1910.
The Episcopal church was hit so hard by the October storms of 1955 that the waters floated the organ up toward the altar. Abandoned after the flooding, it was purchased by local cement magnate A.J. Snyder so that it could be converted into a library. The Rosendale Library Association was granted its charter on October 24, 1958. The building was severely damaged by fire on January 15, 1975. It was restored, and a new wing was added. In 1986, the library was listed in the National Register of Historic Places. (RL.)

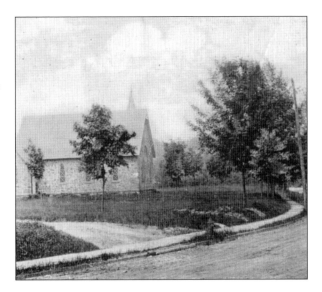

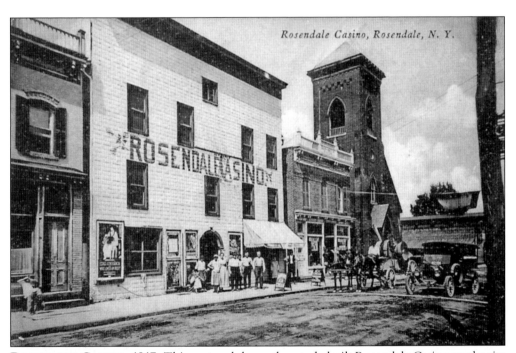

ROSENDALE CASINO, 1917. This postcard shows the newly built Rosendale Casino on the site of what used to be Jake Snyder's Grocery and, later, the Snyder Melleret Company. The older building was destroyed in the fire of 1895. The mule-drawn concrete mixer on the street was probably en route to one of the mills. The autobus no doubt belonged to one of Rosendale's early bus owners, either Ira Bell or Sam Hermance. On the sidewalk are Andrew Smith Jr., Frank Keator, and Harry Baxter. The casino was built by Andrew Smith Jr., who also operated the hotel and barbershop established in the 1870s just across the street by his father, Andrew Smith Sr. The Rosendale Casino was not a gambling establishment, but rather a place for people to gather for recreational and social occasions, such as dances. The building later became the Rosendale Fire House and, in 1949, the Rosendale Theater. (VW.)

A Scene near Rosendale. Mountains, forests, rivers, and streams made Rosendale a favorite vacation and fishing spot for locals and visitors. "The Rondout Creek . . . pronounced by tourists to be one of the most beautiful streams in the country, is filled with the finest specimens of the finny tribe, and the disciples of old Isaac Walton frequently take home with them large number of the finest Black Bass, a fish that has no equal among the edible fishes of New York," reported the *New Paltz Independent* on July 24, 1869. "These fish grow to a great size, having been taken from the creek here weighing 7 lbs." The message on the card reads, "Dear Jr. I am very busy fishing and swimming, so did not send any cards. Our best regards to the folks. John." (GV.)

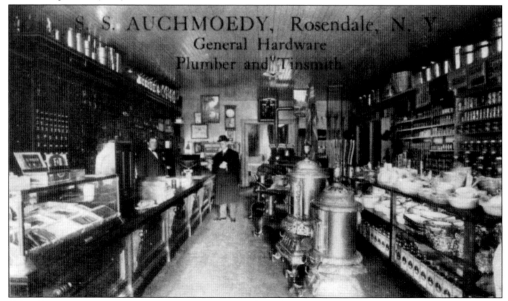

S.S. Auchmoedy General Store. Located at the northwestern end of Main Street, this building was once A.B. Dubois's grocery store before it became Silas Auchmoedy's combination hardware and general store. It was one-stop shopping at its finest in the early 1920s. (1850H.)

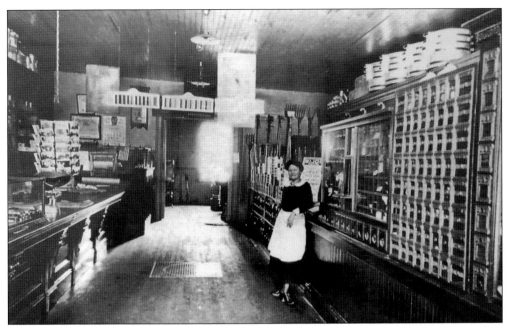

ROSENDALE POST OFFICE AND GENERAL STORE, MAIN STREET. Later, Auchmoedy's general store became a combination Rosendale Post Office and general store. Mail was delivered twice each day. A first-class stamp, for delivery anywhere in the United States, cost 3¢. Mail within the community was delivered for 2¢. The woman in the photograph is Anna Mae Auchmoedy, Rosendale's first town clerk, serving from 1932 to 1957. (RTH.)

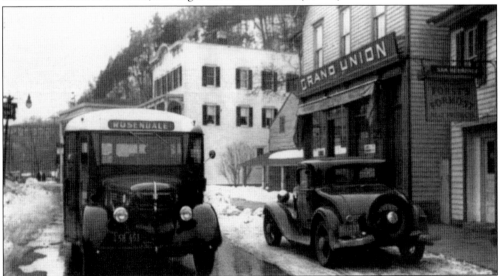

ROSENDALE GRAND UNION, 1930s. The Rosendale Post Office and general store later became a Grand Union supermarket, a chain of grocery stores that did business primarily in the northeastern United States. By the 1930s, it was one of the largest grocery chains in America. The name "Grand Union" was inspired by the desire to "unite shoppers with low prices in a 'Grand Union of Value.'" The building later became the Rosendale Liquor Store. Today, it is the Rosendale Café, a favorite of locals and visitors, with an extensive vegetarian menu, live music, and dances. (RTH.)

GREETINGS FROM ROSENDALE. Scenic vistas made the Hudson Valley and Rosendale a favorite getaway for drivers. In the early 1900s, Robert Spindler of LeFever Falls purchased several parcels of former cement company land at auction and created one of the first of many boardinghouses, helping to transform Rosendale into a popular summer and winter vacation destination. This new resurgence in tourism lasted until the mid-1950s, when construction of the New York State Thruway killed the resort industry in much of Ulster County. Ironically, the Thruway was built using Rosendale cement from A.J. Snyder's Century Cement Company, the last natural cement company in Rosendale. (GV.)

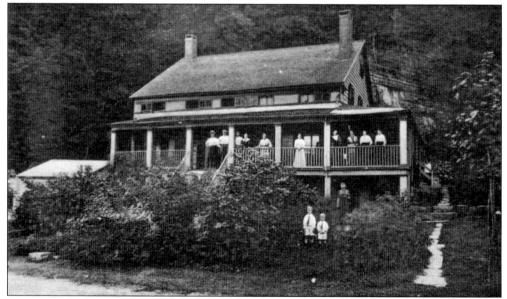

MYER'S BOARDINGHOUSE, 1920s. The Myer family was among the earliest settlers of Ulster County, with relations in Saugerties, Kingston, and Rosendale by the late 1800s. During the summers, the population of Rosendale trebled due to an influx of visitors. Boardinghouses such as this one, established in 1923 and located on the northern central edge of Rosendale backing to Joppenbergh Mountain, remained popular with locals and visitors alike, bringing in much-needed revenue. In the 1930s, this became "the old homestead." Today, the building is a private residence. This card is postmarked 1922. (GV.)

A SCENE NEAR ROSENDALE, 1920S. In 1919, America had 7.5 million cars. By 1929, that number would grow to 25 million. The advent of the motor car opened the beauty of the Hudson Valley to visitors from near and far. Unfortunately, road construction failed to keep pace with the production of cars, forcing early drivers to traverse unpaved roads in almost all of America's rural areas. This card is postmarked December 23, 1930, a few years before Route 32 was built. Printed in the United States, but colorized in Germany, it is decorated with a swastika on the back, which was a symbol of good luck until the 1930s. (GV.)

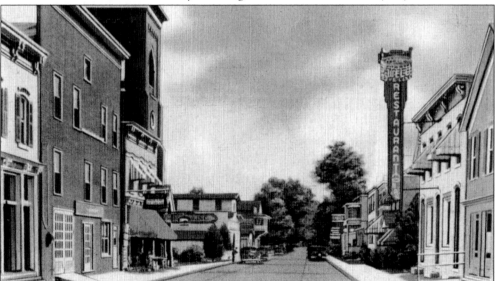

MAIN STREET ROSENDALE, 1930S. In 1930, the population of Rosendale was 2,192, an almost 12 percent increase from the previous decade as tourism and a brief revival of the cement industry revitalized the economy. The Well, on the right, was a bar and restaurant in the 1930s decorated with colorful murals on the interior. In the 1970s, it was owned by Rosendale's colorful William "Uncle Willy" Guldy (who ran for president of the United States) before closing its doors for the final time. The building with the large door on the left was the firehouse. (GV.)

31

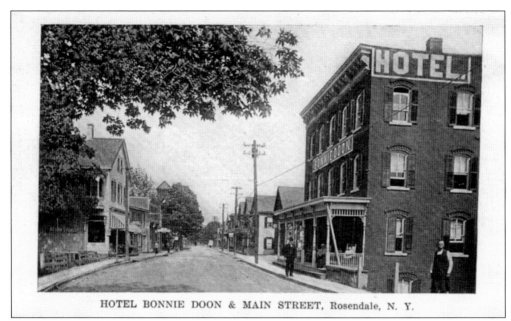

HOTEL BONNIE DOON & MAIN STREET, Rosendale, N. Y.

HOTEL BONNIE DOON. Located on the southwestern end of Main Street on the banks of Rondout Creek, this building has been a hotel since it was first constructed by Conrad Schinnen as the Central House Hotel in 1850 on a foundation of Rosendale cement. Shortly afterward, it was renamed the Schinnen Hotel. In 1910, it was known as Allen McKenzie's Hotel Bonnie Doon. The establishment had room for 50 guests, a ballroom with piano, individual baths, electric lights, and telephones. (1850H.)

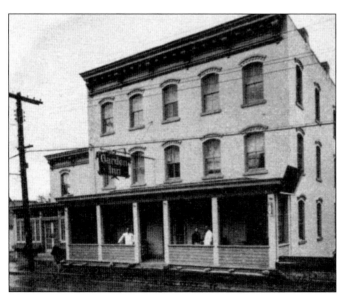

THE GARDEN INN, 1934. Around 1920, the Hotel Boonie Doon became the Hoffman House and later, the Garden Inn. In 1934, the Garden Inn advertised its delicious German cooking and Italian cuisine a la carte. Guests could enjoy the music of Harold Banks and his Virginians while they dined. Overnight rooms were $1 a night, and room and board was $3 a day. A weekly stay was only $16. The hotel advertised "All Modern Conveniences" with dinner, dancing, and a bar and grill. (1850H.)

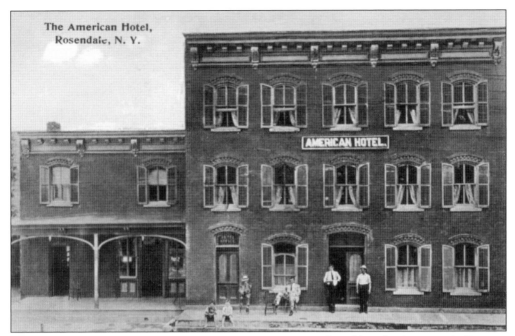

THE AMERICAN HOTEL, ROSENDALE, NEW YORK. Developed by a businessman in Boston, the American Hotel chain was one of the first hotel franchises in the United States. Archie McLaughlin owned the American Hotel in Rosendale, which operated at the turn of the 20th century. (VW.)

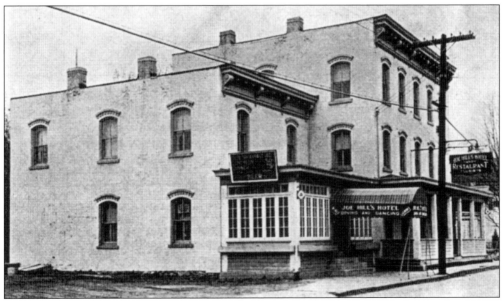

JOE HILL'S HOTEL, 1940s. On December 29, 1940, the building became Joe Hill's Hotel. It charged $3 a day or $16 a week and advertised "Boating & Fishing on our Own Grounds." Joe Hill's Hotel held an annual pig roast in the second week of January that was popular with Rosendale Town residents. (1850H.)

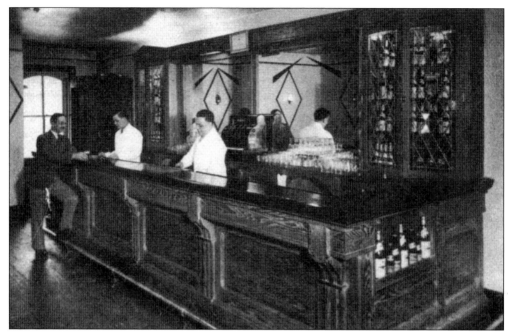

BAR OF THE GARDEN INN, ASTORIA HOTEL. The Astoria Hotel replaced Joe Hill's Hotel. Subsequently, it housed Rosendale Town offices. In 2012, the building was restored and renamed the 1850 House Inn & Tavern. It features stylish guest rooms and an onsite tavern providing an exceptional dining experience. (1850H.)

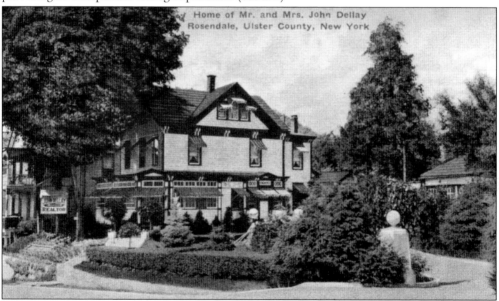

HOME OF JOHN DELLAY AND HIS WIFE, 1930S. John Dellay was of one of Rosendale's preeminent realtors. A larger than life figure, he dealt in farms, boarding houses, bungalows, acreage, and waterfront property. Dellay was one of the few realtors in Rosendale or Ulster County willing to sell property to African American reverend "Father" M.J. Divine in the mid-1930s. Father Divine established 30 interracial religious communities in Ulster County. Locals were always invited to the 5¢ chicken dinners they offered. (VW.)

A SCENE NEAR ROSENDALE, NEW YORK, 1930S. What Rosendale lacked in paved roads in the 1930s it more than made up for with its many rivers, lakes, and creeks, which were ideal for canoeing and other water sports. Boats could be rented throughout Rosendale for rowing or fishing. Rondout Creek, the Wallkill River, and nearby lakes, such as those at Binnewater, were stocked each year with bass, trout, and pike, making them a favorite with fishing enthusiasts. This card, which also bears a swastika on the back, is postmarked December 23, 1930. (GV.)

THE VALLEY INN, 1934. The last building on the northwestern end of Main Street Rosendale was once the Simeon Van Wagnen building. Isaac Keator ran a market there before he accepted a position as a custom's official at the Port of New York. By the 1930s, it was Joseph Nikoletich's Valley Inn, which was advertised as a "Fine Place for your vacation. Summer and Winter Resort. Bar and Grill, Music, Dancing, Bathing and Fishing, Outdoor Bowling" and "Best Home Cooking." (1850H.)

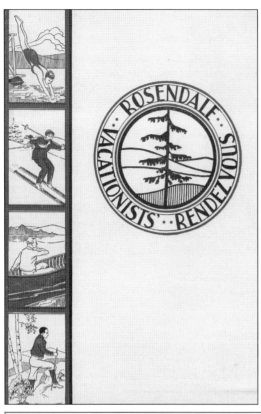

FRONT COVER OF "VACATIONIST RENDEZVOUS" PAMPHLET. This is the 1936 cover of the Rosendale Township Association's 32-page pamphlet, which listed Sports & Recreation, Points of Interest, Transportation, and Accommodations available in the Rosendale area. The township believed that "the unlimited natural resources of the community form an ideal setting for a Summer-Winter Vacationland." Resort owners pledged themselves to "maintain a high standard for their individual resorts and to act collectively in promoting activities for the comfort and entertainment of all guests of resorts." Aimed at attracting tourism, Rosendale's marketing campaign was advanced for its day and successful. (RL.)

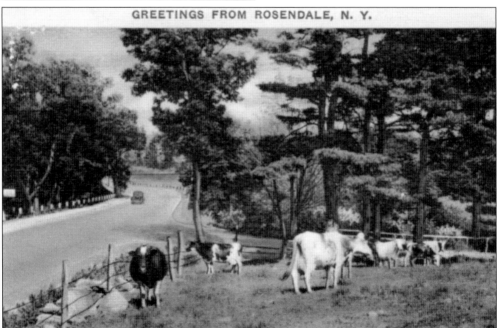

GREETINGS FROM ROSENDALE, 1940S. Even in the 1940s, Rosendale, surrounded by farms and apple orchards, retained its bucolic charm. The back of this card reads, "Enjoying a week's vacation here. I am well & hope you are the same." The card is postmarked July 3, 1940. (GV.)

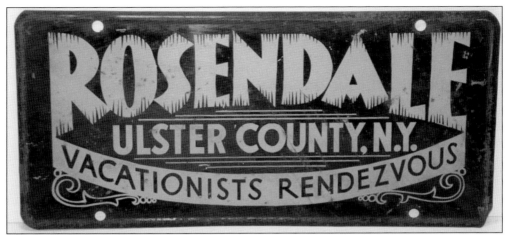

VACATIONIST RENDEZVOUS LICENSE PLATE, 1940S. During the 1940s, Rosendale marketed itself aggressively as a vacation destination with the tagline "Rosendale Vacationist Rendezvous." Booklets were printed regularly listing the many activities available in the area (hiking, swimming, fishing, summer and winter sports, and more) along with boardinghouses, restaurants, and cafes. License plates like this one were manufactured in support of the marketing campaign. (CHHS.)

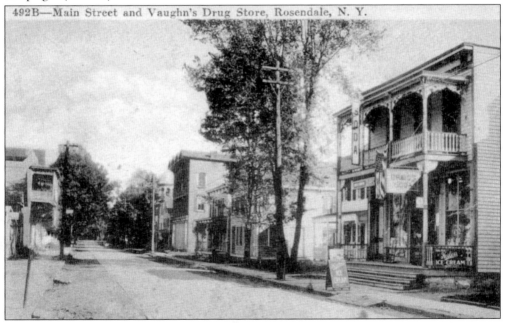

492B—Main Street and Vaughn's Drug Store, Rosendale, N. Y.

MAIN STREET AND VAUGHN'S DRUG STORE, ROSENDALE, NEW YORK, 1940S. This scene of Main Street looks northeast. J. Wilbur "Doc" Vaughn ran the drugstore, Rosendale's de facto community center. Vaughn was elected mayor of Rosendale several times. All the medicines and pharmacy paraphernalia were on the left under a glass counter as you entered. On the right was a marble ice cream fountain. Vaughn had no competition in the pharmacy business. But across the street was Baxter's newsstand and ice-cream emporium. Later, Baxter's became Gilmartin's luncheonette and soda shop. Vaughn's went out of business in the 1970s, followed by Gilmartin's in the 1980s. Today, Vaughn's is an apartment building. The "Rx" on the wrought-iron railing remains to this day. Gilmartin's is now the Big Cheese café. (RL.)

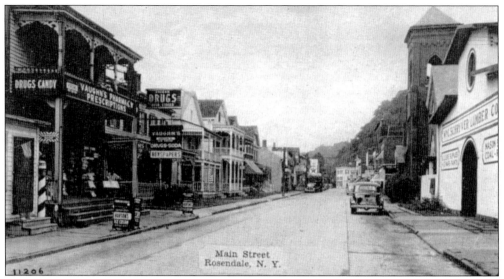

MAIN STREET ROSENDALE, 1943. This view of Main Street looks southwest. Many of the buildings had apartments with porches on the second floor. Downstairs were grocery stores, cobblers, barbershops, coffee shops, a hardware store, a drugstore, a bus station and a cab stand. The William Schryver Lumber Company, on the right, replaced the LeFever Lumber Company. Today, it is the Red Brick Tavern. The Rosendale Dutch Reformed Church stands next to it, flanked by Baxter's soda shop, followed by the firehouse (later, the movie theater). Vaughn's pharmacy stands across from the lumber yard. In the distance at left is Henry Myer's garage, marked by the Texaco star. In the distance at center is Joe Nikoletich's Valley Inn. (VW.)

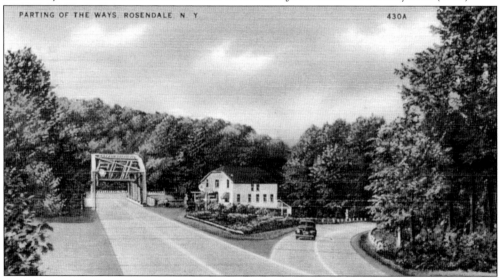

PARTING OF THE WAYS, ROSENDALE, 1940s. This postcard depicts the bridge over Rondout Creek and the intersection of Route 32 (on the left) and Main Street Rosendale (on the right). The building, a residence and tavern, the Bridge View Inn, was operated by Rosendale's Frank Nosenzo and his wife. After falling into disrepair, it was torn down, and the land was donated to the village by the new owner to build the brick pump station for the Rosendale Flood Control Project. Today, the small redbrick Rosendale Pumping Station and the Veteran's Memorial occupy this spot. (VW.)

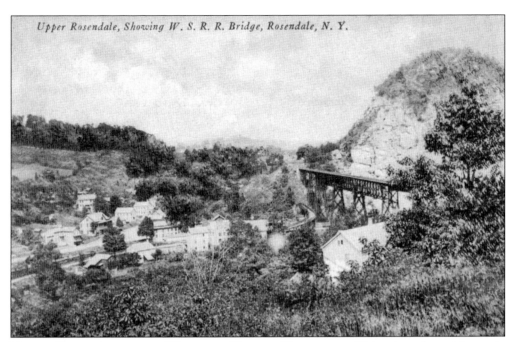

Upper Rosendale, Showing W. S. R. R. Bridge, Rosendale, N. Y.

UPPER ROSENDALE AND WALLKILL VALLEY RAILROAD. This view from Mountain Road is looking northeast. Lawrenceville is below. The Wallkill Valley Railroad Bridge and Joppenbergh Mountain are on the right. (1850H.)

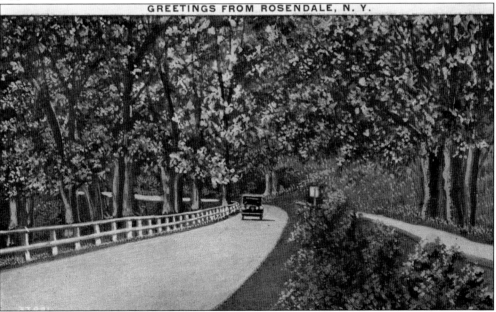

GREETINGS FROM ROSENDALE, N. Y.

GREETINGS FROM ROSENDALE. The beautiful scenery of the Catskill Mountains attracted tens of thousands of visitors to Ulster County and Rosendale each year. On April 19, 1940, the Rosendale Township Association sponsored its first Rosendale Reunion, reuniting people from Rosendale with those who had spent their vacations there. The event was held at the Gloria Palast, a popular German-Austrian cabaret-restaurant in New York City. The following year, 900 people attended the reunion. This card is postmarked July 20, 1954. (GV.)

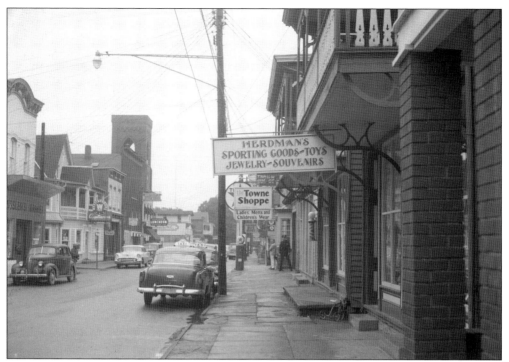

LOOKING EASTWARD ON MAIN STREET ROSENDALE, 1950S. The Reformed Dutch Church is visible on the left. Gilmartin's Luncheonette stands next to it. Rossler's Market, a Main Street landmark for many years, is in the foreground. (CHHS.)

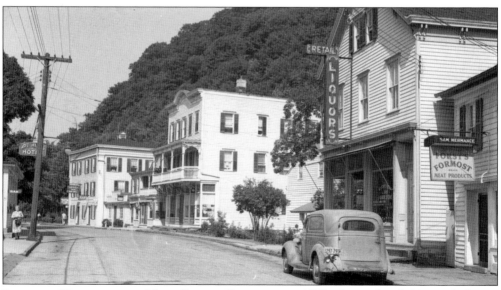

LOOKING WESTWARD ON MAIN STREET ROSENDALE, 1950S. Joppenbergh Mountain looms over Main Street with few cars on the road. Joe Hill's Hotel is barely visible on the left. Across from it and a bit down the road is the Valley Inn. (CHHS.)

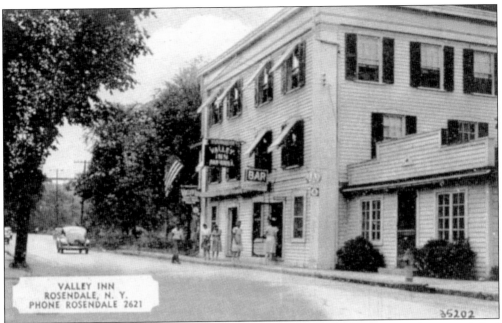

VALLEY INN
ROSENDALE, N. Y.
PHONE ROSENDALE 2621

VALLEY INN, ROSENDALE, 1950s. The Valley Inn remained open well into the 1950s. It had accommodations for 40 guests "with all modern improvements for year-round comfort." Today, the building is empty and awaiting a new tenant. The Nettle & Violet, a vintage clothing store, occupies the smaller building on the right of the former inn. (VW.)

GREETINGS FROM ROSENDALE, 1950s. Autumn in the Hudson Valley has always been spectacular. Visitors come from across America and all around the world to see the fall foliage. Rosendale offered (and continues to offer) thousands of acres of heaven on earth, with mountains, cliffs and caves, forest and fields, rivers and streams, and lakes and ponds. Guests could explore many miles of carriage roads and trails for hiking, running, mountain biking, and horseback riding. For the more intrepid, the Shawangunk Mountains offered rock climbing routes. This card is postmarked August 17, 1956. (GV.)

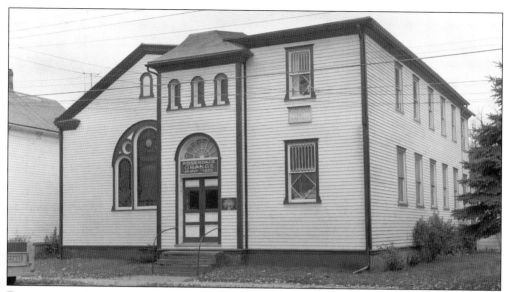

ROSENDALE GRANGE ON MAIN STREET, 1950S. Originally the Baptist Church, the Rosendale Grange building was located on the southwestern end of Main Street. Founded after the Civil War in 1867, the National Grange is the oldest agricultural advocacy group in America. In addition to its weekly Monday meetings, the Rosendale Grange held events, such as patriotic lectures, card parties, dances, and lunch auctions, where the gentlemen could purchase a box lunch and have as a luncheon partner the lady whose name was written in a slip of paper inside the box. Abandoned for many years, the Rosendale Grange building burned down in the winter of 2004. (CHHS.)

GREETINGS FROM ROSENDALE, 1950S. Rosendale's cold and snowy winters made it an ideal winter destination for skiing, ski-jumping, and ice skating, along with competitions for the serious sportsman or woman. The winter sports season opened in late December with ice skating at Williams Lake (every day and night) and regular "swims" by the Williams Lake Polar Bear Club. Other activities included the Telemark Ski Club jumping tournament on the Rosendale ski hill (Joppenbergh). By the late 1930s, the club was one of the strongest in the United States Eastern Ski Association. (RL.)

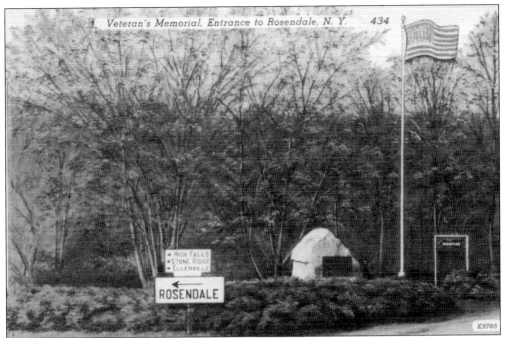

VETERAN'S MEMORIAL, ENTRANCE TO ROSENDALE, NEW YORK. Men and women from Rosendale have fought in all of America's wars. Civil War veteran John J. Birmingham, buried with full military honors in Rosendale in October 1939, witnessed the assassination of President Lincoln in Ford's Theater in Washington. Two men from Rosendale are said to have perished with George Armstrong Custer at the Battle of Little Big Horn on June 25, 1876. This memorial, located at the northeastern entrance to Main Street, has since been expanded to remember all Rosendale veterans who have died fighting for their country. (VW.)

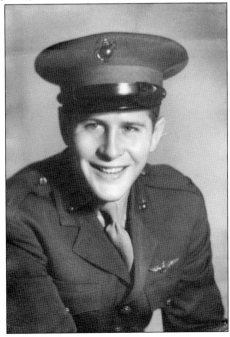

CAPT. GEORGE DUFFY. On Memorial Day 2002, Rosendale dedicated the George Duffy Memorial in Veteran's Park. A lovely gazebo, built by the Rosendale Women's Club, serves as a permanent reminder of Marine pilot Capt. George Duffy of Rosendale. Duffy, who was on a routine training flight for the Marine Corps Reserve, was killed on June 11, 1952, when he swerved his Navy fighter to avoid striking bystanders during a crash landing at the Bonnie Briar Country Club at Mamaroneck. (HHHC.)

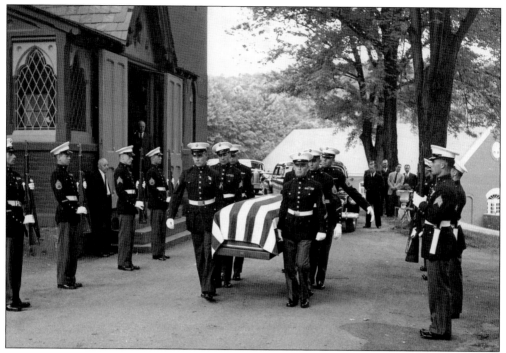

THE FUNERAL OF CAPT. GEORGE DUFFY, ROSENDALE, NEW YORK. Duffy's funeral service was held at St. Peters Church. Hundreds of grieving relatives, friends, and neighbors attended. Fourteen US Marine fighters from Duffy's Marine fighter squadron flew over Rosendale in formation in tribute to the captain. Six of the planes returned and flew over the village in the form of a cross. Captain Duffy was buried with full military honors. (HHHC.)

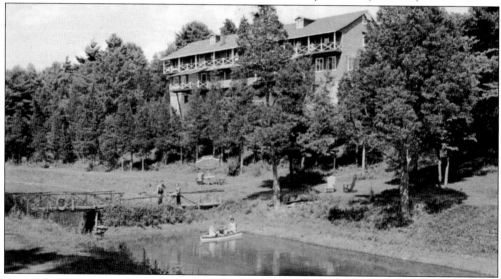

SUNRISE–HILLCREST LODGE. Located at the top of Mountain Road in Rosendale, Sunrise Hillcrest Lodge advertised itself on the back of this postcard as "A Beautiful Vacation Spot at the Top of the Mountain. Rooms with Private Bath; Also Modern Motel Rooms. Beautiful Swimming Pool. Weekend Guests Welcome. Swiss Management." The property, shown here in the 1960s, was managed by the Kuenzlers. Today, it is known as Sky Lake Lodge. (VW.)

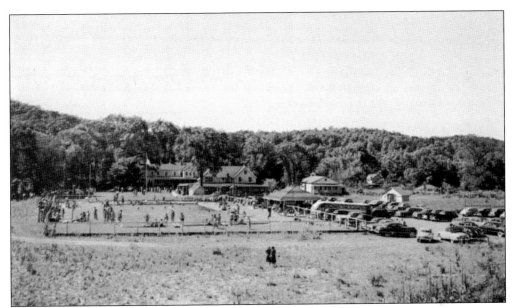

SPORTSMEN'S PARK SUMMER, EARLY 1950S. During the hot New York summers, many locals and their children gravitated to Sportsman's Park, home to Rosendale's 150-by-60-foot public swimming pool, capable of holding 400,000 gallons of water. It also had a wading pool for children, a refreshment stand, and a large parking area in the 1950s. (GV.)

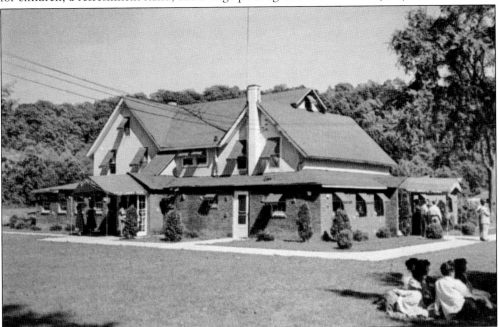

SPORTSMEN'S PARK SUMMER RESORT. Sportsmen's Park also featured a restaurant, dining room, and cocktail bar with piano entertainment. Today, a new swimming pool and picnic complex, along with a baseball field, basketball and tennis courts, youth center, and the Rosendale Recreational Center, occupy this location just off Route 32. The recreation center serves as the venue for the annual Rosendale International Pickle Festival and other events. It is also the local polling station and a venue for social events and town meetings. (VW.)

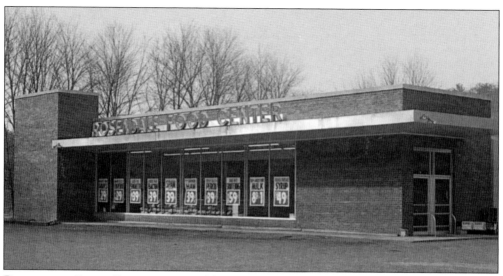

ROSENDALE FOOD CENTER. Rosendale's first modern supermarket was built on the town's former Washington Park, where George Washington camped with his troops in November 1782 en route from West Point to Port Jervis during the American Revolutionary War. The Continental Army discovered that the British were burning Kingston and withdrew back to West Point. British general Sir Henry Clinton is also said to have camped his army on this same spot. Today, My Town Market Place occupies the building. (GV.)

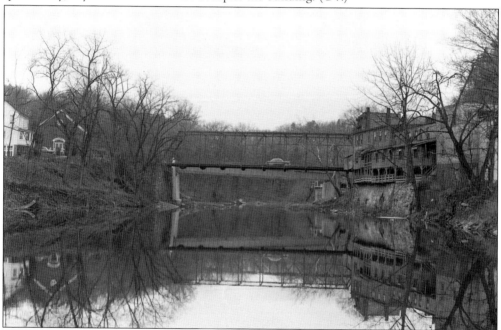

RONDOUT CREEK AND CREEK BRIDGE, ROSENDALE, NEW YORK, 1950s. Looking westward up Rondout Creek at the Creek Bridge. This bridge replaced a previous single arch metal bridge, which was destroyed in 1878 by high winds of hurricane proportions, which also caused considerable damage to the Black Smoke Mill on Joppenbergh Mountain. Prior to that, a wooden covered bridge stood on the same site until it was destroyed by a flood. The St. Peters Church Hall is on the left. (CHHS.)

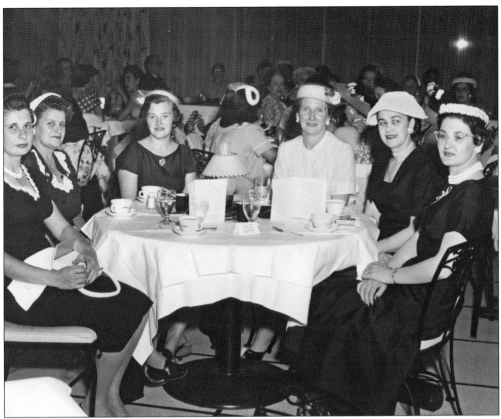

ROSENDALE'S WOMEN'S CLUB 25TH ANNIVERSARY DINNER, MAY 1957. Rosendale's Women's Club was organized in 1932 to erect a monument to World War I veterans. It went on to realize many other civic and beautification projects. The group was instrumental in the creation of the Rosendale Library, donating books, furniture, and "woman power." The organization is still going strong today. From left to right are Dorothy Mastro, Lottie Burns, Emma Pezzello, unidentified, Helen Mathews, and Beverlee Mulligan. (RL.)

MAIN STREET ROSENDALE, MAY 24, 1958. A prosperous Main Street is pictured in the late 1950s. The Rosendale Theater, the Old Dutch Reformed Church, and Gilmartin's Luncheonette are visible on the left; the Well Restaurant, the Texaco station, and the Trailway's Bus Depot on the right. Although most of the signage has changed in 60 years, Main Street remains much the same. (1850H.)

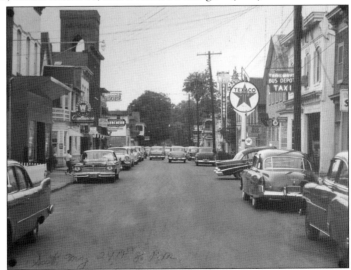

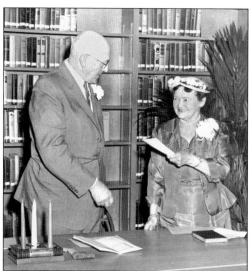

ROSENDALE LIBRARY CHARTER.
Anna Mae Auchmoedy, president of the
Rosendale Library Association, accepts
the deed to the library building (formerly
All Saints Chapel) from Andrew J. Snyder
of Century Cement Co., April 13, 1959.
The Rosendale Library was established in
1958 in Rosendale's old Episcopal church.
Andrew J. Snyder was the library's main
benefactor and supporter. (RL.)

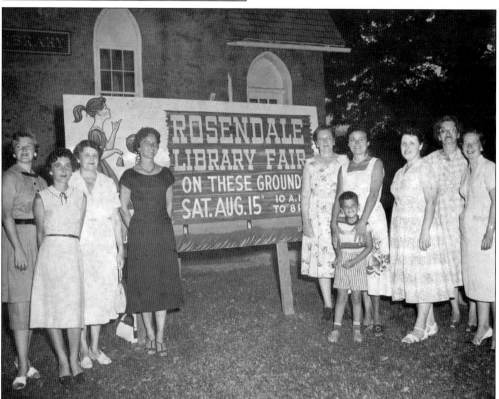

ROSENDALE LIBRARY FAIR STAFF, JULY 1959. The first Rosendale Library Fair was held
in August 1958 in preparation for the library's dedication in April 1959. Over 150 people
volunteered. Sixteen booths raised $1,300 over two days. Library fairs with various themes
continued for about 30 years until the library received its Special District designation in 1988.
From left to right are Emma Pezzello, Mrs. Robert Murphy, Lottie Burns, Mrs. Donald Doyle,
Hazel Kloepfer, Lorette and little Peter Morelli, Marion VanWinkle (later Sickles), Mrs.
Herman Miller, and Peg Donnelly. (RL.)

YARTER WEDDING, AUGUST 14, 1960. The Yarters were one of many young couples who celebrated their wedding reception at the Astoria Hotel on Main Street Rosendale. (1850H.)

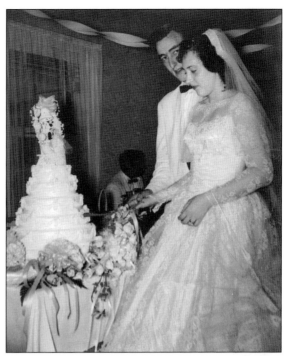

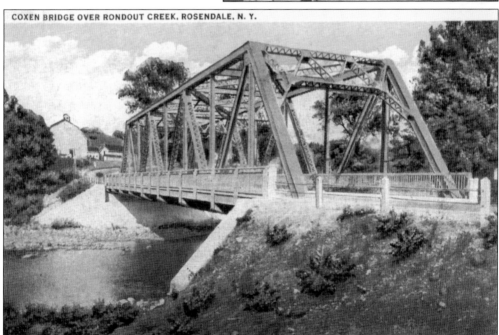

COXEN BRIDGE OVER RONDOUT CREEK, ROSENDALE, N. Y.

COXEN BRIDGE OVER RONDOUT CREEK, ROSENDALE, NEW YORK, 1966. Rosendale has 16 bridges. This one spans Rondout Creek between Lawrenceville and High Falls on Route 213. The original Coxen Bridge was one of Rosendale's three covered wooden bridges. It collapsed in 1928 after severe flooding damaged the southern abutment and was replaced with an all-metal bridge in 1932 and then again with a steel bridge, shown on this postcard, in 1966. The current bridge was built in 1997. (RL.)

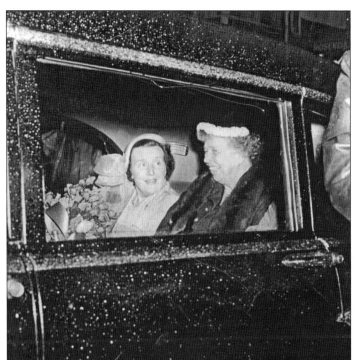

ELEANOR ROOSEVELT TOURS ROSENDALE. Many people, great and small, visited Rosendale throughout its history, including political leaders, royalty, and actors. Franklin Delano Roosevelt and his wife traveled through Rosendale several times. In this undated photograph, Eleanor Roosevelt tours Rosendale Village. (HHHC.)

QUEEN JULIANA OF THE NETHERLANDS. Juliana was queen of the Netherlands from 1948 until her abdication in 1980. In 1952, she visited the United States and New York City, where she was welcomed with a parade on April 7. Prior to her return to the Netherlands, she asked that her wishes and appreciation be particularly extended to the community of Rosendale, for the kind welcome she was shown when she visited. The *Rosendale News* reported, on April 25, 1952, "Her Majesty stated that she will remember Rosendale as the small village that presented her with the greatest and most spontaneous welcome of all the many places she visited." (GV.)

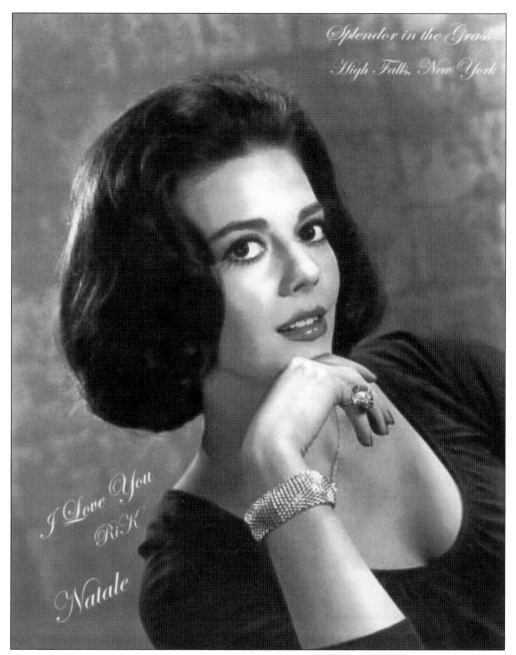

NATALIE WOOD. Natalie Wood, Robert Wagner, Joan Collins, and Warren Beatty were in High Falls filming scenes for the 1961 three-time Oscar-winning film *Splendor in the Grass*. (HHHC.)

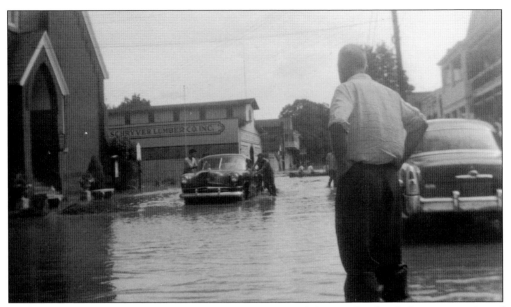

FLOODWATERS, MAIN STREET ROSENDALE. Rosendale was hit hard during a series of America's worse weather-related disasters. The floods of August 1955, resulting from back-to-back Hurricanes Connie (August 12–13) and Diane (August 18–19), dropped 17 to 19 inches of rain on the northeastern United States, leaving one dead and six injured in New York State with damage to bridges, roads, and property estimated at more than $ 16 million. Excessive rainfall and high floods continued throughout October as storms swept New York and southern New England, especially the Esopus Creek basin, which saw another 17 inches of rain. Main Street Rosendale was flooded and closed to traffic in the aftermath. (RTH.)

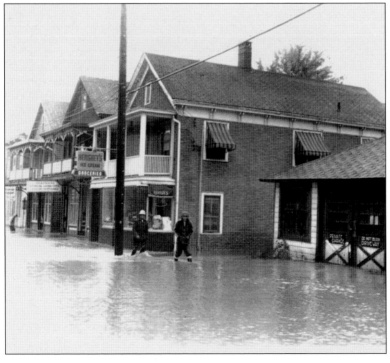

FLOODING, MAIN STREET ROSENDALE. During the August 1955 floods, many buildings suffered a "terrific loss," according to the *Kingston Daily Freeman*, which reported, "Many buildings along the creek will need new foundations. Most of them will have to be completely rewired." (RTH.)

Two

TILLSON
(ROSENDALE PLAINS)

Rosendale Plains is a hamlet about a mile and a quarter south of Rosendale. It was occupied before the American Revolutionary War. By the 1870s, it contained a hotel, blacksmith shop, a trotting course, and 10 dwellings. In 1898, a post office was established here. Rosendale Plains was later renamed Tillson, as almost all the land in the area was owned by a man of that name. Job Tillson was a scout for the Continental Army during the Revolutionary War when he was 12 years old. The location of his home on Tillson Road, is marked with a New York State historical marker. Tillson was the most heavily populated hamlet of Rosendale. Its early settlers were primarily Dutch, English, and French farmers of Huguenot stock. The hamlet remained rural through the beginning of the 20th century, uninfluenced by any of the successive tides of immigration. It supplied nearby industrial centers with much of the skilled tradesmen of the period. Tillson was home to many weavers, printers, carpenters, bricklayers, foremen, blacksmiths, butchers, masons, storekeepers, tinsmiths, and contractors.

Just a little message
To a dear friend of mine
That J may be remembered
As a true friend of thine

MAIN ST. TILLSON, N.Y.

PUB. BY KSS AN KSS PHOTO CO., INC

MAIN STREET TILLSON, NEW YORK, EARLY 1900s. At the corner of Route 32 and Gristmill Road, this was one of Rosendale's first post offices. Today, it is The Postage Inn, one of the town's popular eating and drinking establishments. (VW.)

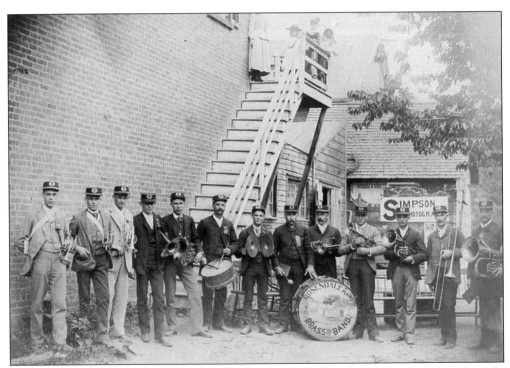

ROSENDALE PLAINS BAND, LATE 1800s. Music was an important part of rural and small-town life in America in the 19th and 20th centuries. Rosendale was, for many years, a musical center of considerable note. Before the 1900s, the town had four township bands, five drum corps, and some half dozen orchestras. These, augmented by numerous vicinity musical organizations, provided the tempo for the frequent picnics, balls, outings, private parties, and political parades. The members of the Rosendale Plains Band included Willis Keator, Myron Owens, Oliver Keator, Silas Freer, Eugene Keator, Oliver Carter, Tracy Keator, Walter Keator, and Leon Clark. (CHHS.)

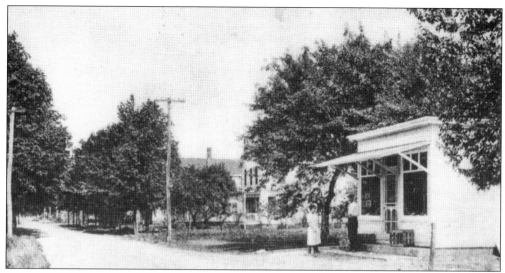

TILLSON GENERAL STORE, 1870. This building predated the larger Tillson General Store at the intersection of Tillson and Elting Roads. In the late 1800s, Tillson had three general stores selling dry and non-perishable goods with long shelf lives. Canned goods were not widely available until after the Civil War in 1865. Van Camps beans in tomato sauce were particularly popular. Beer, whiskey, molasses, and vinegar were dispensed through spigots from barrels. Ginger beer was available for teetotalers, women, and children. Establishments like these also carried non-food items and were more of a general store than a food vendor. (JJ.)

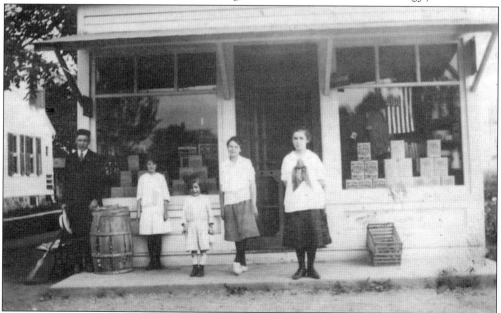

FAMILY AT THE TILLSON GENERAL STORE, 1870. This is most likely the Christiana family, who owned and ran the store. General stores like these were stocked with grains, beans, flour, and some spices, along with crackers or biscuits. Customers could stock up on dried legumes from bushel baskets on the floor. Cheese, eggs, butter, and freshly baked goods were available, as were tea, coffee, wine, and chocolate. Some stores sold dried or potted meat. However, fresh vegetables, fruits, and meats had to be purchased at farm stands and butcher shops. (JJ.)

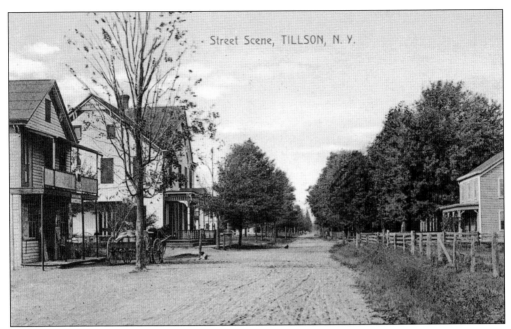

Street Scene, TILLSON, N.Y.

STREET SCENE, TILLSON. This view looks north on Elting Road. The first building on the left was the Tillson General Store until it closed its doors. In the early 1900s, it was Keator's Grocery, afterward Bagley's, then the Tillson Market. The houses on the left and the right are still there and appear unchanged after more than 100 years, as does the field on the right. Further to the right, not visible on this card, is the Tillson Fire Station. This card is postmarked August 31, 1910. (GV.)

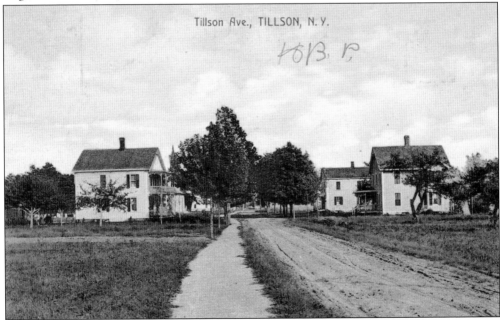

Tillson Ave., TILLSON, N.Y.

TILLSON AVENUE. The scene of Tillson Road looks east. Note the Friends Church Steeple to the right of the house on the left. The postcard, which was printed in Germany, has been dated July 13, 1905, by the sender. (GV.)

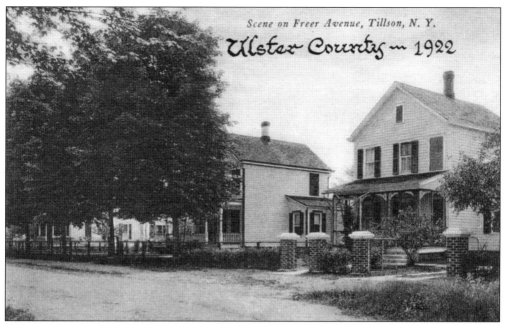

Scene on Freer Avenue, Tillson, N. Y.

Ulster County — 1922

A Scene on Freer Avenue. This colorized postcard shows Tillson in the early 1920s. Today, Freer Avenue is Route 32. The same houses are still standing, though many of the trees have been cut down, and the brick posts in front of the first house have been removed. This postcard is dated August 1922. (VW.)

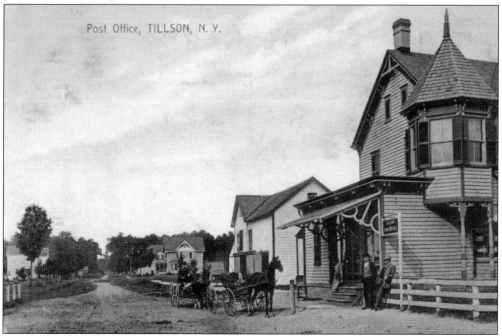

Post Office, TILLSON, N. Y.

Post Office, Early 1900s. The Tillson Post Office was established in 1898 on the corner of Gristmill Road and Hardenbergh Avenue. Before it was the post office, it was Charles Myer's Grocery Store. Postmasters were political appointments and moved when a new party was elected to office. The postcard is postmarked February 18, 1913. (VW.)

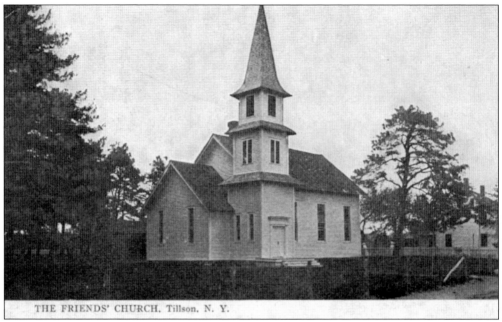

THE FRIENDS' CHURCH, Tillson, N. Y.

THE FRIENDS CHURCH, EARLY 1900S. Located on Gristmill Road, Tillson's Friends Church was built in 1800. The Friends, or Religious Society of Friends, were Quakers, one of the oldest religious denominations in America. The Tillson and Coutant families were especially active with the Friends Church. Phebe Tillson, the first minister, is commemorated with a New York State historic marker in front of the church, which is still a house of worship today. The card is postmarked July 12, 1915. (GV.)

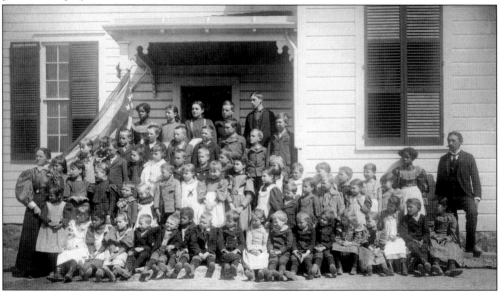

TILLSON SCHOOL HOUSE CHILDREN. Teachers and schoolchildren of the Tillson School are pictured in the early 1900s. Under the Common School Law of 1812, New York State developed a statewide system of public schools. Common or public schools in this period focused on the "3 R's" ("readin,' 'ritin', and 'rithmatic"). More advanced instruction was available in private high schools known as academies or seminaries. (HHHC.)

Three

ROSENDALE CEMENT

Rock for hydraulic cement (which hardened underwater) was discovered in High Falls in 1825 during the construction of the Delaware & Hudson Canal. In the spring of 1826, John Littlejohn, under contract to provide cement for construction of the D&H Canal, began quarrying, burning, and grinding the first cement. The growth of Rosendale and its natural cement industry was explosive. In 1836, the village contained only 10 or 12 dwellings and a single hydraulic cement factory owned by W.E. Lawrence, which employed 100 to 200 men and produced 500 barrels a day. By the 1840s, 13 companies operating 16 cement works were mining and processing what became known as Rosendale hydraulic natural cement between High Falls and Rondout, producing 600,000 barrels annually. The cement was used in the construction of cisterns, well cellars, the Croton Aqueduct system, and various other North American government projects. One of the largest producers was the Newark & Rosendale Lime and Cement Company at Whiteport, which employed 180 men and could produce 1,000 barrels a day. The cement rock was quarried through tunnels 200 feet long and 130 feet deep. The rock was then heated in 15 kilns and ground in mills whose three-foot grinding stones were turned by waterwheels and steam engines. A horse railroad carried the barrels of cement to the navigable waters of the Rondout Creek. The cement was then shipped to New York City and throughout the United States. In his 1880 *History of Ulster County, New York: with illustrations and biographical sketches of its prominent men and pioneers*, Nathaniel Bartlett Sylvester wrote:

> The quarries, with their long tunnels, piercing deep into the mountainsides; the sharp precipices; the beautiful lakes; the rough, craggy hillsides; the secluded glens, and the wild ravines—have a thousand attractions. The busy scenes of labor, the hundreds of workmen, the frequent explosions in the blasting or rocks echoing along the mountainsides, the ceaseless clang of the mills . . . all add to nature's pictures, and continually blend the 'useful with the ornamental.'

By 1899, Rosendale was producing almost 10 million barrels of natural cement, or about 25 percent of all the natural cement produced in North America, annually. According to reports of the US Geological Survey, Rosendale cement led the nation during most of the more than 150-year span of the natural cement industry, at times accounting for 50 percent of all the natural cement manufactured in the United States and Canada. Rosendale cements were ranked among the best in quality of all cements in America. By the early 1900s, however, Rosendale natural cement had fallen from favor as it was replaced by Portland cement, which dried faster, thus speeding construction. Furthermore, while Rosendale cement consisted of a single type of limestone, Portland cement was made of several different types that were more readily available nationwide and thus did not have to be shipped great distances.

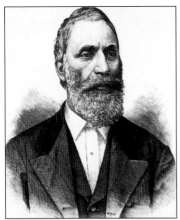

ANDREW J. SNYDER, 1896. Rosendale owes much of its growth, prosperity, and recognition to Andrew Jacob Snyder. His father was the first to map Ulster County. Born on July 5, 1823, in Hurley, A.J. Snyder worked on the Delaware & Hudson Canal before going to work for the Newark & Rosendale Cement Company as superintendent. In 1850, Snyder began operating his own cement plant. Rosendale grew and prospered with Snyder cement. Snyder died on January 10, 1902, leaving behind his mansion, estate, and a declining Rosendale cement industry. (JHBC.)

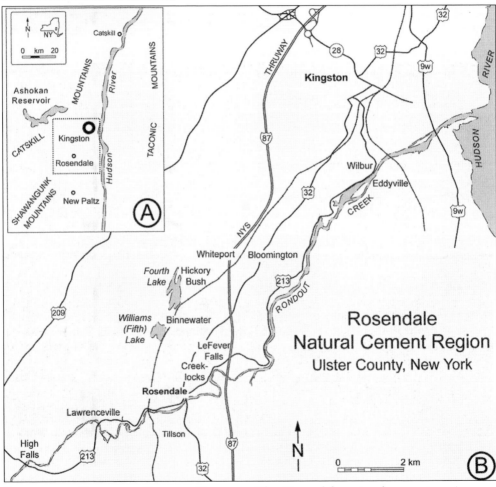

ROSENDALE NATURAL CEMENT REGION. The Rosendale natural cement region was discovered and brought into being in 1825 through the need of cement mortar for construction of the Delaware & Hudson Canal. An 1896 government report stated that of all the natural cement then produced in 15 states, about half came from New York and nearly all of this came from the Rosendale district, with 15 plants operated by 12 companies. (CHHS.)

INTERIOR OF CEMENT CAVE, NEW YORK. In 1825, the first cement discovered in the area was used to build the D&H Canal. Thereafter, Rosendale's cement industry brought booming business to the canal, while the canal facilitated the shipment of cement to New York City and, from there, across the United States. Annual cement production quadrupled between 1850 and 1870. This scene, of the "Widow Jane" mine, located on the Century House Historical Society grounds, is from the early 1900s. (VW.)

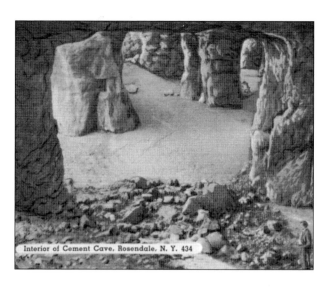

Interior of Cement Cave, Rosendale, N. Y. 434

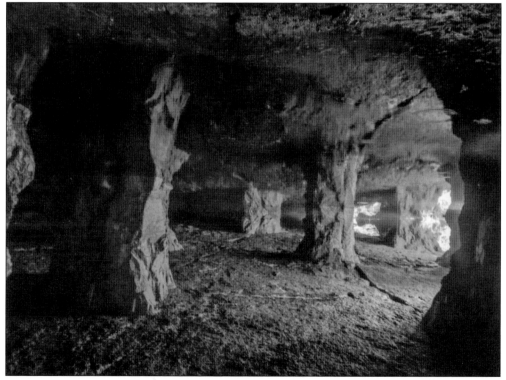

INTERIOR VIEW OF THE WIDOW JANE MINE, LATE 1890s. During much of the 19th century, miners used sledgehammers, drills, black powder, and room-and-pillar mining techniques to extract dolostone from the Rosendale cement mines. Despite technological advances, such as pneumatic drills, the use of room-and-pillar mining techniques persisted throughout the entire course of the cement industry in Rosendale. Room-and-pillar mining left a carefully arranged array of pillars to support the ceilings of excavated spaces. The mining process extended the original main shafts deeper into the mine before connecting them with an additional row of rooms. (CHHS.)

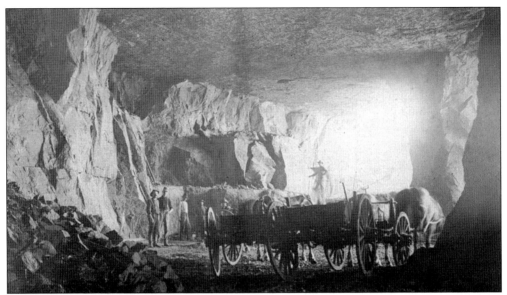

ANOTHER INTERIOR VIEW OF THE WIDOW JANE MINE. Mine entrances had to be large enough to accommodate horses and wagons to remove the limestone and waste rock. (CHHS.)

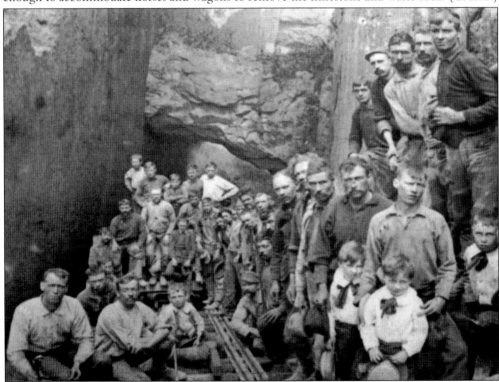

CEMENT WORKERS. Men and boys toiled in Rosendale's cement mines for much of its history. During the period of Industrialization, child labor was the norm, making up as much as 20 percent of the workforce. Many parents had no choice but to send their children to work as their meager wages helped to support the families. Working children had no time to play or go to school and little time to rest. Many were injured or killed in mining accidents. (CHHS.)

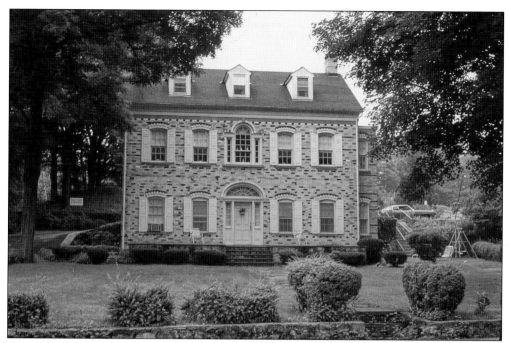

ANDREW J. SNYDER HOUSE. A.J. Snyder was president of the Rosendale and Lawrence Cement Companies. His house, located along Rondout Creek and Route 213 between Rosendale and Lawrenceville, sits on an estate of 275 acres. Also known as the Ceramic Brick House, it was originally built in 1887 as a Second Empire–style mansion, complete with mansard roof. In 1950 the windows and roof were converted to a more standard gable with dormers. It was also refaced in polychrome glazed brick imported from Leeds. The Snyder Estate is in the New York State Landmark Register. (LoC.)

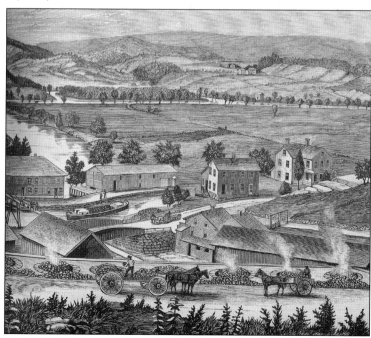

LAWRENCE CEMENT COMPANY WORKS AT ROSENDALE. The Lawrenceville Cement Company could manufacture 125,000 barrels of cement a season. It employed about 130 men. The mills had access to both the Delaware & Hudson Canal and the Wallkill Railroad, facilitating transport and distribution of the cement throughout New York State and the Northeast. (CHHS.)

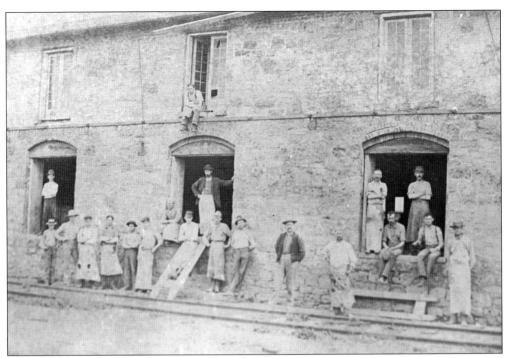

WORKERS AT A ROSENDALE CEMENT COMPANY BUILDING. Cement workers like these, many of them Irish, German, Austrians, and Italian, toiled constantly, risking life and limb for low wages. In May 1867, about 1,000 manual laborers of the Binnewater, Greenkill, Rosendale, Rock Lock (LeFever Falls), High Falls, Lawrenceville, and Whiteport cement mills went on strike demanding higher wages. Anticipating trouble, three companies of the State National Guard were mobilized by Rosendale sheriff Silas Saxton. Despite news reports to the contrary, the strike was resolved without any violence. (CHHS.)

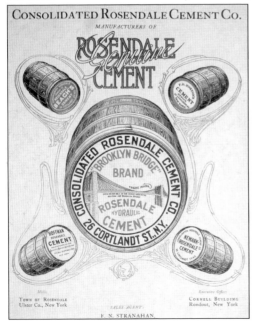

ADVERTISEMENT FOR THE CONSOLIDATED ROSENDALE CEMENT COMPANY. The fact that the Brooklyn Bridge is advertised dates this after 1883, when the bridge, which was built with Rosendale cement, was completed, and probably to the late 1880s, when the Rosendale cement industry was booming. By industry's peak in 1898 and 1899, the Rosendale district was producing four million barrels of cement annually (or 40 percent of total US cement production) and employing more than 5,000 workers in 30 factories. (CHHS.)

CEMENT BARREL AT THE CENTURY HOUSE MUSEUM IN ROSENDALE. Barrels like these were used for packing and transporting cement. Each barrel held approximately 300 pounds of cement. In one week in April 1872, the Rosendale Cement Company shipped 1,500 barrels of cement to California via Cape Horn. The requirement for four million barrels of cement annually gave rise to a huge cooperage and blacksmithing industry in the region, consuming vast amounts of wood, iron, and coal. (GV.)

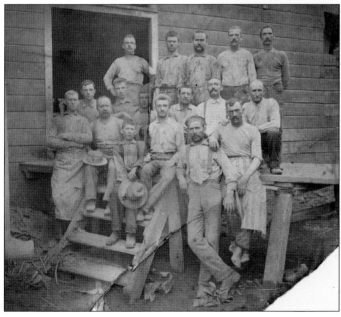

COOPERS. In addition to the thousands of cement workers, tens of thousands of others in the region worked to support the industry. Coopers and blacksmiths, as well as transportation workers, were essential in getting Rosendale natural cement to Rondout and New York City on canal boats, trains, and Hudson River craft. (1850H.)

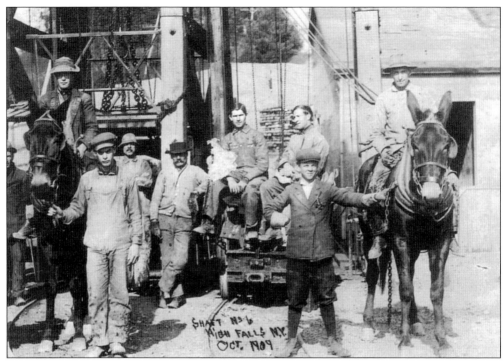

ROSENDALE CEMENT MINERS, BLACK SMOKE CEMENT QUARRY, 1890S. At its peak, the Rosendale cement industry on Joppenbergh Mountain employed more than 5,000 workers, mining, producing, packaging, and moving cement. Mineworkers went on strike regularly to demand better wages, the $1.20 a day they were receiving in 1897 at the peak of production not being considered enough "to keep soul and body together." At the time, the average American worker made less than $2 a day. A highly skilled worker earned $3 a day. The cost of living was $600 a year. (RL.)

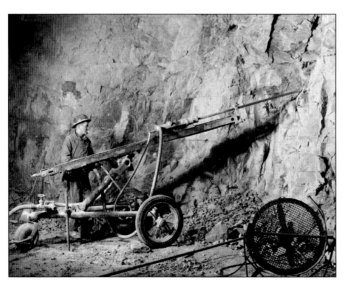

HYDRAULIC ROCK DRILL. Developed in 1849 by American inventor J.J. Couch of Philadelphia, hydraulic rock drills like this one replaced sledgehammers and black powder. They were relatively light and easy to use. Powered first by steam and later by compressed air, the hydraulic drill allowed a team of workers to mine dolostone much faster and more efficiently and was also safer than dry drills. (CHHS.)

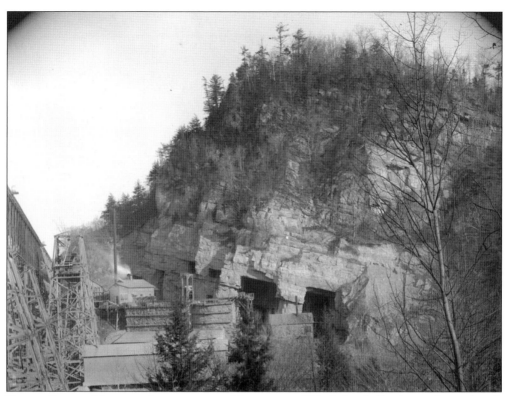

BLACK SMOKE MINE ON JOPPENBERGH MOUNTAIN. "Black Smoke" mine on Joppenbergh Mountain opened in the early 1870s, rapidly growing into a large-scale manufacturing facility. Down in the depths of Rosendale's most famous mine was a scene of almost unbelievable interest; hundreds of men and horses, machinery of all sorts, the clatter of tools, the roar of railcars speeding over miles of tracks, and the thunder and vibration of heavy blasts. The all-pervading black smoke that dimmed the torches from which it rose gave the mine its name. (CHHS.)

ROSENDALE, NEW YORK, 1888. This is an early view of Joppenbergh Mountain to the northwest of Rosendale. The 500-foot mountain was mined throughout the late 19th century for dolostone, used in the manufacture of natural cement. The base of the mountain is dotted with cement mines and caves. (VW.)

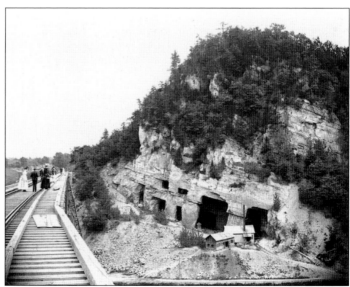

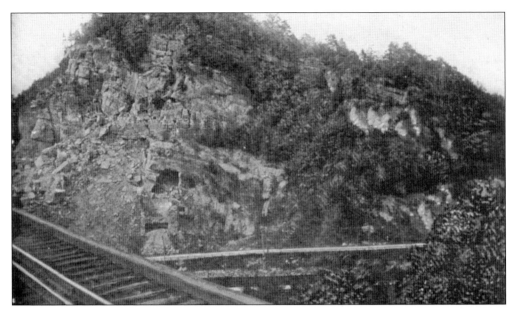

JOPPENBERGH MOUNTAIN AFTER THE CAVE-IN. Extensive mining caused a large cave-in on December 19, 1899, destroying equipment and collapsing shafts within Joppenbergh. Fortunately, the disaster occurred during the lunch break, and the few employees present were outside; thus, no casualties occurred. Since the collapse, the mountain continues to experience shaking and periodic rockfalls. (1850H.)

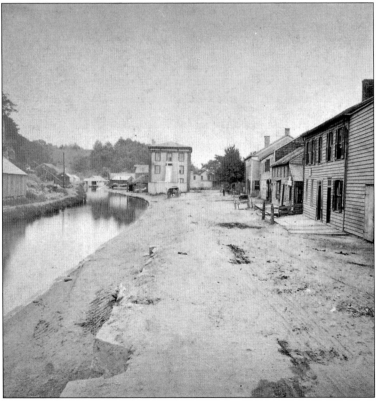

LOOKING EAST TOWARD D&H CANAL AND MAIN STREET ROSENDALE, EARLY 1900S. The fortunes of Rosendale rose and fell with its natural cement industry. Following the collapse of the industry, many businesses closed shop and workers and families moved elsewhere looking for work. Rosendale looked like a ghost town, as evidenced by this image. (CHHS.)

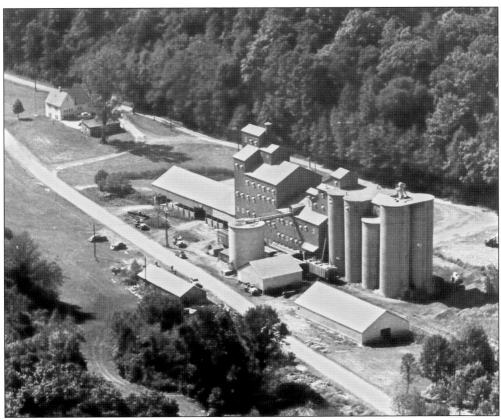

CENTURY CEMENT MANUFACTURING COMPANY PLANT, 1955. Rosendale cement existed as a legal entity until March 1982 in the form of the Century Cement Manufacturing Company, Inc., which was formed in November 1934. Located in Rosendale, it was the successor to the Lawrence Cement Works, which later became the Beach Cement Works, which in turn became the Snyder Cement Works. Following World War II and continuing into the 1950s, Rosendale natural cement found a special niche in the cement market. (CHHS.)

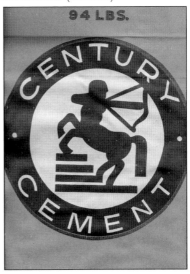

CENTURY PORTLAND CEMENT BAG. Bags like this held approximately 94 pounds of cement. In 1954, Century Cement shipped the equivalent of 452,252 barrels of natural cement and an additional 190,000 barrels of masonry cement. The US government, along with New York and four other states, adopted the Rosendale-Portland blend for certain construction jobs. During this period, Snyder's cement was used in such large-scale projects as the St. Lawrence Seaway, the Chicago West-Southwest Sewage Treatment Works, the New York State Thruway, and a number of federal and state dams. In 1970, A.J. Snyder II closed the last cement plant in the Rosendale district, ending Rosendale's 145-year-old industry. (CHHS.)

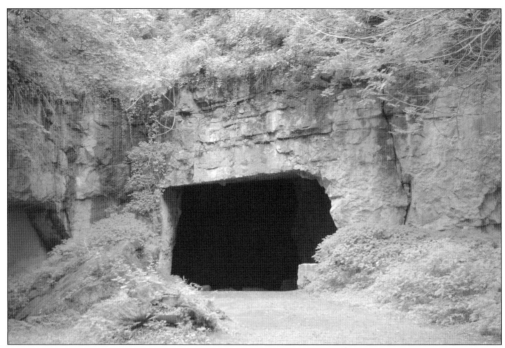

ENTRANCE TO THE WIDOW JANE MINE TODAY. Today, the Widow Jane mine is open to the public. A venue for concerts and other events, this iconic mine even has a popular whiskey named after it. (GV.)

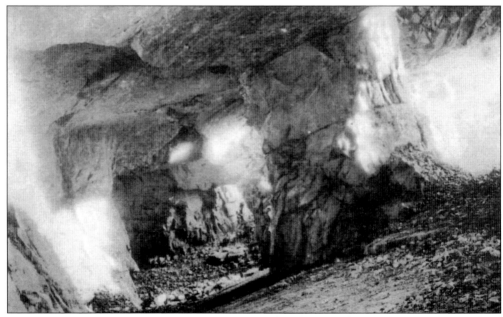

INTERIOR OF THE WIDOW JANE MINE TODAY. This photograph provides a good example of room-and-pillar mining, which left a carefully arranged array of pillars to support the ceilings of excavated spaces. (CHHS.)

WAGON CAVE, ROSENDALE, NEW YORK. Following the decline of the Rosendale natural cement industry, the quarries and caves were used to store corn and grow mushrooms. Wagon Cave is located at the western entrance to Rosendale near the intersection of Keator Avenue and Route 213. (1850H.)

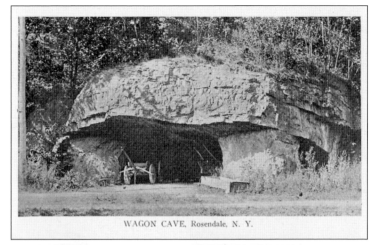

WAGON CAVE, Rosendale, N. Y.

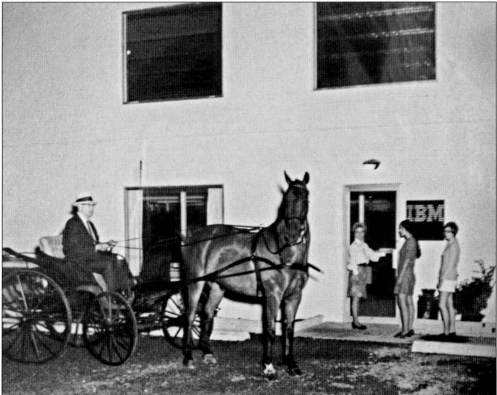

A.J. SNYDER II AT THE IBM UNDERGROUND STORAGE FACILITY. A.J. Snyder II loved horses and could be seen out and about in horse and buggy even in the 1970s. In December 1966, construction of an ultramodern top security storehouse in a 32-acre section of the old cement mines and caves in Binnewater marked the beginning of a new chapter in Rosendale's history. Large companies discovered that the underground mines provided excellent protection for documents from fires, floods, and even nuclear attack. IBM was one of the first to take advantage of the local cement mines for storage. Later, Iron Mountain opened a facility in Binnewater for the storage of records, microfilm, valuables, and other items in what is today a small underground city. (CHHS.)

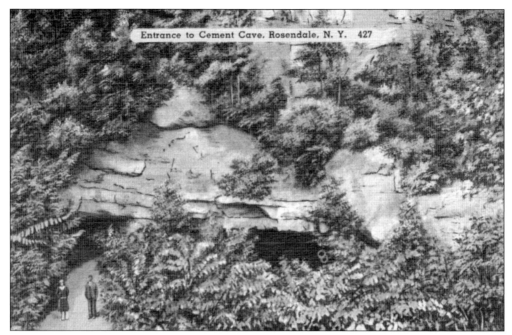

ENTRANCE TO CEMENT CAVE, ROSENDALE, NEW YORK. According to Rosendale town lore, there is an elaborate 65-room hotel beneath the cement mines. Built in the mid-1950s, each modern bedroom has a private bath. The facility is also equipped with a commercial kitchen. In the event of a nuclear war, New York City executives, along with their families, would have arrived via helicopter to Iron Mountain Atomic Storage Incorporated in Rosendale to wait out the atomic storm underground. Today, the cement mines remain a popular tourist attraction. (1850H.)

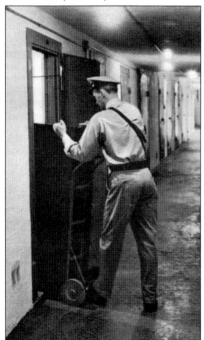

IRON MOUNTAIN ATOMIC STORAGE. A guard places valuables in storage in 1955. Constructed in 1951, the first Iron Mountain Atomic Storage vaults cost $1 million to build and were advertised as the "safest place in the world." They consisted of more than one million cubic feet of bomb-proof, water-proof, burglar-proof, temperature- and humidity-controlled storage space, situated deep in an old iron mine. The networked tunnels were secured by a 28-ton vault door. The concrete-lined tunnels were air-conditioned and contained private walls, which could be rented for storage. Today, Iron Mountain operates facilities throughout the United States, including Rosendale, and in 50 countries.

Four

The Delaware & Hudson Canal

When construction of the Delaware & Hudson Canal began in 1925, the builders were planning to have cement shipped from Madison County, near Syracuse. This was an expensive proposition. However, when blasting began on the property of Jacob Low Snyder (current site of the Century House Museum in Rosendale), limestone was discovered that would give rise to the area's largest 19th-century industry. The success of the Rosendale natural cement industry depended upon access to the D&H Canal, which connected the township to national markets and fuel in the form of coal. Thus, local companies had a significant cost advantage over cement factories in competing regions and could deliver their product at a lower cost. As a result, the market for high-quality and relatively inexpensive Rosendale cement continued to grow, eventually including all major Atlantic ports and the West Indies.

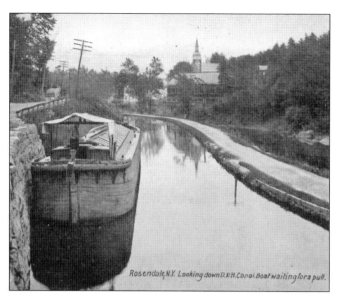

Rosendale,N.Y. Looking down D.&H.Canal.Boat waiting for a pull.

LOOKING DOWN D&H CANAL BOAT, EARLY 1900s. The Delaware & Hudson Canal, which paralleled Rondout Creek to the north in Rosendale, was the first venture of the Delaware & Hudson Canal Company. Between 1828 and 1899, the canal's boats, one of which can be seen on this postcard, carried cement from the mines of Rosendale and Ulster County to the Hudson River and then to market in New York City. The view is looking east toward St. Peter's Church. The dirt path on the left is now Route 213. (RL.)

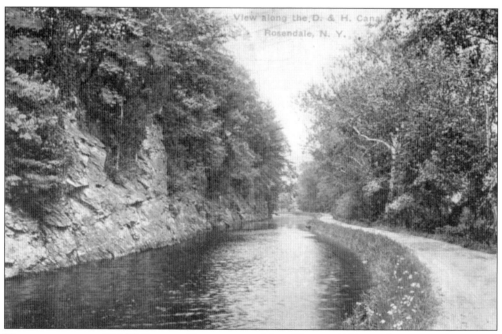

VIEW ALONG THE D&H CANAL, ROSENDALE, NEW YORK, 1890. In the 1890s, this was an eerie point, which most hesitated to travel alone at night. There were no houses or roads in the area—only darkness and silence, which favored the superstitious. The "Haunted Scow" rotted in the basin, and according to local lore, a ghostly girl appeared nightly on its decaying deck. She had been murdered somewhere along the canal aboard this boat. Because of her nightly appearances, it was abandoned along the waterway, where its decrepit appearance excited curiosity for many years. (RL.)

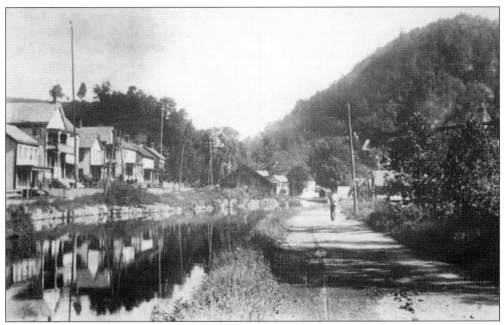

D&H Canal at Lawrenceville. Construction of the canal involved major feats of civil engineering, leading to the expansion of new technologies, particularly railroads and the telegraph. Its operation stimulated the growth of both New York City and the counties through which it ran, encouraging settlement in sparsely populated areas. (CHHS.)

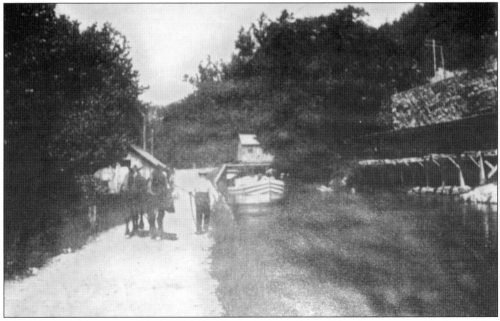

D&H Canal Lock 9 and Cement Kilns at Lawrenceville. During the heyday of the D&H Canal, some 1,100 canal boats plied its waterways at any one time. Most boats were family owned and operated. Many hauled coal from Pennsylvania. Others transported local products. In the 1840s, boats like these carried about 40 tons of cargo. In 1850, each boat cost $400 to $450 to construct from oak and lasted for five years. (CHHS.)

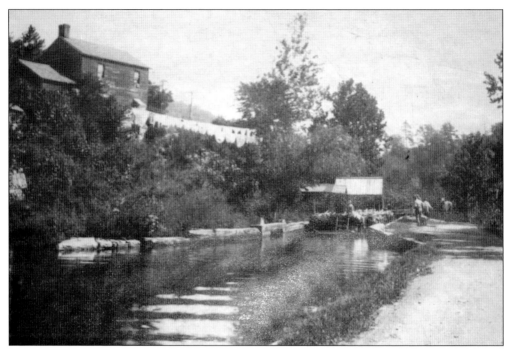

LOOKING EAST AT LOCK 9, LAWRENCEVILLE. After the canals were widened and deepened in 1847, canal boats, measuring 90 feet long and 14 feet wide (and costing $1,800 each) carried 140 tons, allowing for faster delivery of greater quantities of Rosendale cement to New York City. Many of the large boats could navigate the Hudson River, reducing the expense of unloading at Rondout near Kingston. (CHHS.)

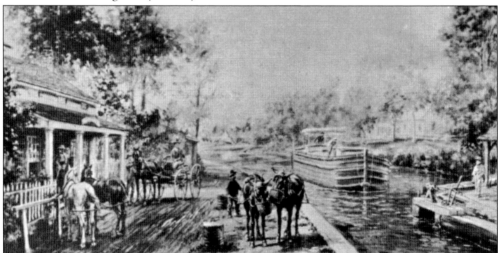

E.L. HENRY PAINTING OF D&H CANAL. Equines were the real heroes of the D&H Canal. Boats were pulled by mules or horses along the adjacent towpath; a power source employed even after the development of steam engines. The hardworking beasts walked up to 3,000 miles in a single season. In the beginning, a single horse was enough to pull a canal boat carrying 30 tons. Later, after the canal was enlarged and loads increased, two or three mules were required. The canal company employed about 600 mules in the 1870s. An average of two were lost each day to accidents. (GV.)

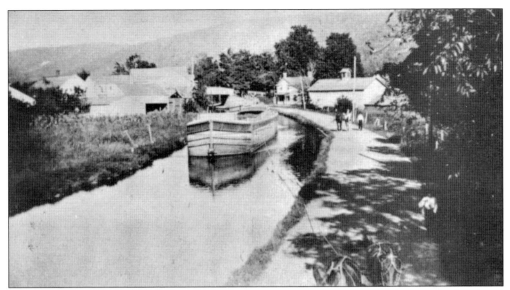

CHILDREN LEADING MULES ON D&H CANAL TOWPATH. At first, children were often hired to lead the mules. Later, grown men were employed. They had to walk 15–20 miles each day, pump out the barges, and tend the animals, all for $3 a month. The work was not without its risks. In 1874, eleven people drowned in the canal, many of them children. Boat masters frequently showed indifference to the fate of the children they employed. (GV.)

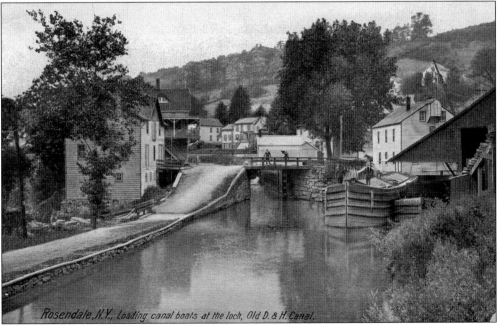

LOADING CANAL BOAT AT THE LOCK, OLD D&H CANAL. The Ferguson lock section of the D&H Canal is seen here as it looked in the 1890s. On the right are two canal boats, side by side, as well as the overhang or apron of the beach loading dock. Two "canallers" can be seen on the deck of the outermost boat. At the left, behind the hand railing and short plank bridge, is one of the numerous "waste weirs," which regulated the height of the water. The card is postmarked Sunday, July 19, 1908. (GV.)

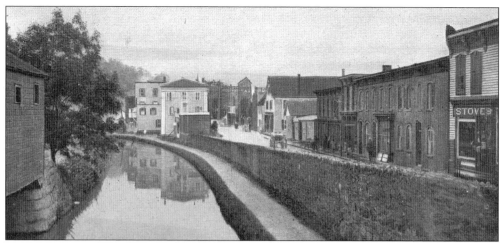

MAIN STREET FROM CANAL BRIDGE, EARLY 1900S. Despite this idyllic image, Rosendale was at its lowest economic ebb in the early 1900s. All the cement mills were closed, and the economic outlook was grim. Stagnant water filled the canal. Weeds and grass covered the once busy towpath. About half of the town's inhabitants had departed with many others soon to follow. Numerous stores and dwellings were empty. The stone abutment seen projecting on the center-left of the postcard is a portion of the foundation of the James B. James Cement Company's loading shed. It is still there today. The company had three quarries in Rosendale. This card is postmarked September 24, 1908. (GV.)

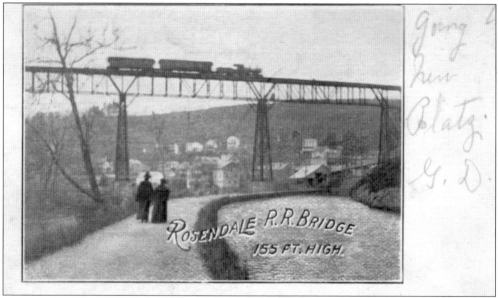

ROSENDALE RAILROAD BRIDGE AT 155 FEET HIGH, 1910. This view of the old D&H Canal shows "Dead Man's Stretch" between Main Street Rosendale and Lawrenceville. Overhead, the Lake Mohonk Special is crossing. According to local lore, numerous drownings occurred along this much-used section of the towpath as nearly everyone that traveled this way preferred the canal route over the poorly maintained highway. There were no electric lights, and the kerosene lamps set along the route were of little value. Various stories were associated with this fatal point, all of which purported the place to be haunted. It was along here that the legendary white dog and other apparitions were seen by night travelers. (RL.)

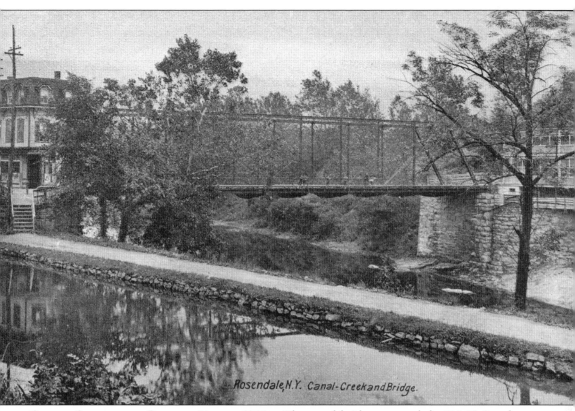

Rosendale, N.Y. Canal-Creek and Bridge.

CANAL CREEK AND BRIDGE, EARLY 1900S. The canal bridge spanned the D&H Canal at the eastern edge of town. Construction of the Erie Railroad through the Delaware Valley in 1848 heralded the end of the canal days, although the D&H Canal continued to be successful through the 1870s and 1880s before it was finally abandoned. The card is postmarked November 1908. (GV.)

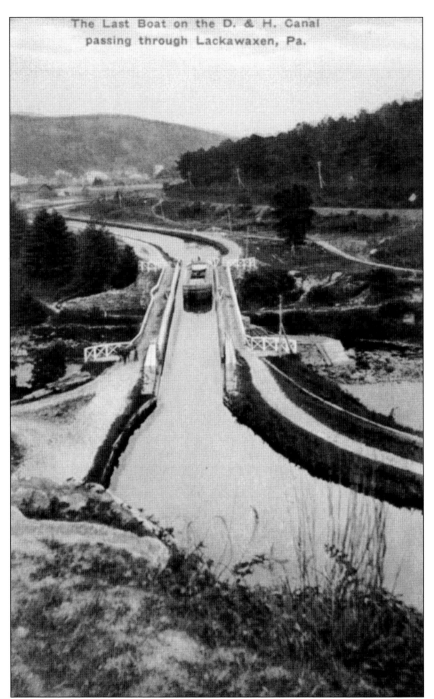

The Last Boat on the D. & H. Canal
passing through Lackawaxen, Pa.

LAST BOAT ON THE D&H CANAL. In 1898, the last boat carried its final load on the D&H Canal. Railroads could transport coal and cement faster, cheaper, and across New Jersey to New York City rather than via Kingston. The following year, after the states authorized the company to abandon the canal and concentrate on their railroad interests, the D&H Canal Company dropped the "Canal" from its name. The canal finally closed in 1902 after 74 years of service. (GV.)

Five

THE WALLKILL VALLEY RAILROAD BRIDGE

Founded in 1866, the Wallkill Valley Railroad was constructed to match the Erie Railroad's six-foot gauge in order to transport goods from one railroad to the other. It was operated by the Erie Railroad for the next 10 years after its construction. The railroad came to New Paltz in 1870, bridging Rondout Creek and the Delaware and Hudson Canal in 1872. Construction of the Wallkill Valley Railroad through Rosendale heralded the end of the D&H Canal. Railroads could move goods faster and cheaper, sending them directly to New York City. If cement put the town on the map, Rosendale's Wallkill Valley Railroad Bridge, a wonder of its day, kept it there.

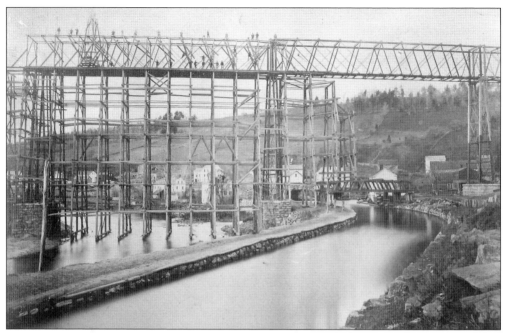

CONSTRUCTION OF THE WALLKILL VALLEY RAILROAD BRIDGE OVER THE RONDOUT, 1871. Built between 1869 and 1871, the Wallkill Valley Railroad Bridge at Rosendale, the highest and longest curved trestle bridge in America at the time, opened for business on April 11, 1872. The wood-and-iron bridge spanned the waters of the Rondout Creek and the D&H Canal. When completed, it was 988 feet long and soared 150 feet above the creek. (CHHS.)

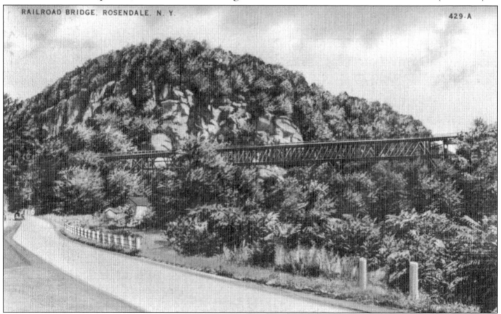

ROSENDALE RAILROAD BRIDGE, EARLY 1900s. In 1896, the wood and iron bridge was replaced with an all-iron construction without any delay of traffic and with only one casualty. The *Kingston Freeman* called the railroad bridge at Rosendale "an iron wonder" representing the "triumph" of "thought" over "nature." This card is postmarked June 22, 1911. (VW.)

**A Stereoscopic Plate
of Wallkill Railroad
Bridge Supports.** The
Rosendale railroad bridge
was later upgraded to all
steel construction. The
New York State engineer
called the final steel bridge
"magnificent." (CHHS.)

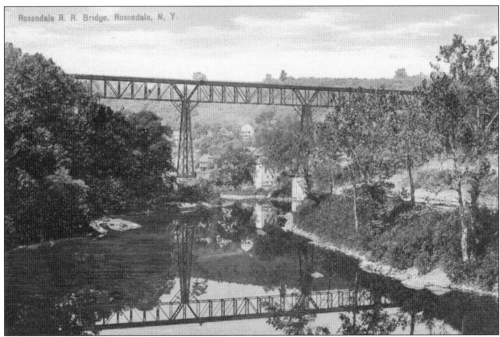

Railroad Bridge over Rondout Creek. The *New York Times* reported that the Rosendale trestle bridge was "the highest span bridge in the United States." The day it opened for traffic, The *New Paltz Independent* reported, "The fame of its wonderful railroad bridge have spread the name of Rosendale over all of the surrounding country." A crowd of 3,000 to 4,000 braved the mud to flock to Rosendale on foot and horseback to see this new wonder. Many brave souls even traversed the bridge on the railcars. The card is postmarked 1935. (GV.)

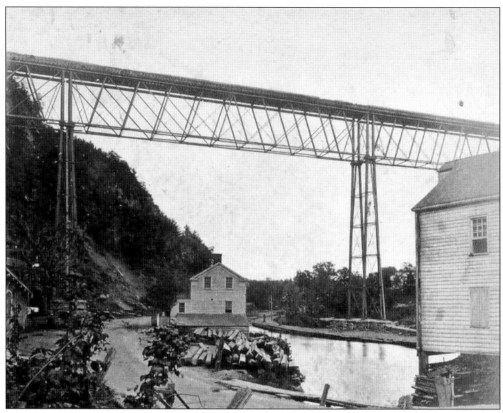

WALLKILL VALLEY RAILROAD BRIDGE OVER THE RONDOUT. By October 1872, Wallkill Valley trains were regularly traversing the bridge en route to Kingston, where connections could be made to Hudson River shipping as well as to a new railroad, the still-growing Ulster & Delaware. By 1880, there were four daily trains traveling from Rosendale as far south as New York City and north to Kingston and Rondout on the Hudson River. The card is postmarked August 1945. (CHHS.)

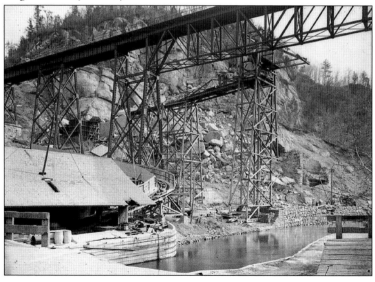

CEMENT MINE. Under the Wallkill Valley Railroad Bridge, cement mining continued as trains roared overhead. (CHHS.)

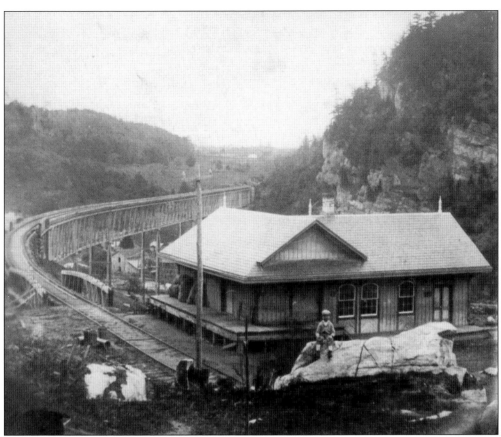

STEREOSCOPIC CARD VIEW OF THE ROSENDALE TRAIN DEPOT. In 1872, shortly after construction of the Wallkill Railroad Bridge, a train depot was constructed on Depot Hill in Rosendale. Located on the south side of Rondout Creek at the bottom of what is today Mountain Road, it provided coal and water for trains transiting the bridge. Rufus Snyder was Rosendale's first local station agent. The station was an important center of local business and pleasure. On Sundays, Rosendale youth would gather there to watch the train arrive. Afterward, they would walk across the old wooden bridge with its wide-spaced ties and unguarded string sides. A fire destroyed the original depot around 1924. (CHHS.)

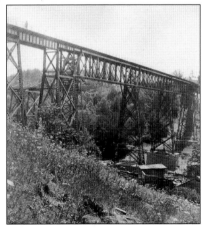

WALLKILL VALLEY RAILROAD BRIDGE. This photograph shows the final all-metal bridge that replaced the first wooden construction. Notice the cement mill buildings below the bridge to the right. The bridge abutments, which are still there today, were constructed of Rosendale cement and are as solid today as the day they were built. (CHHS.)

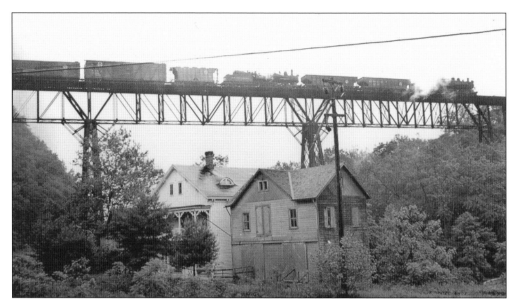

TRAIN GOING OVER THE ROSENDALE TRESTLE BRIDGE. Steam engines carrying heavy loads over the bridge caused the catwalk on the west side of the bridge to shake. By 1975, the rail line had deteriorated to the point where federal regulations allowed only eight-mile-per-hour traffic over the trestle. However, engineers were instructed to only go as fast as five miles per hour. The sturdiness of the bridge, specifically the stability of its piers, was a deciding factor when Conrail (formerly the Consolidated Rail Corporation, which owned the Wallkill Valley Railroad) closed the bridge in 1977. (CHHS.)

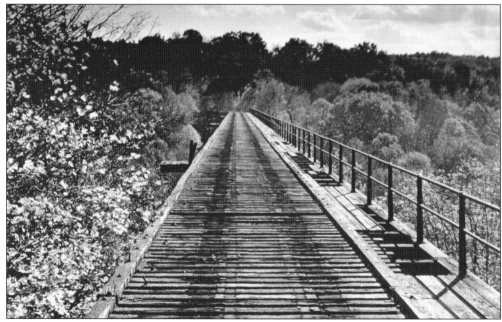

WALLKILL VALLEY RAILROAD BRIDGE, ROSENDALE. After the rail line's closure, Conrail sold the bridge in 1986 for $1 to a private businessman, who tried unsuccessfully to operate the trestle as a bungee jumping platform in the 1990s. The property was seized by the county in 2009 for nonpayment of taxes. (CHHS.)

Six

BINNEWATER AND WILLIAMS LAKE

Located two miles north of the village of Rosendale, Binnewater was originally called Keator's Corners, after Garden Keator, an old resident of the hamlet. Settled prior to the Revolutionary War, one of the distinctive features of Binnewater is a chain of small lakes, numbered one through five north to south. Today, Binnewater has several surviving historic buildings, including a general store and post office (established by the Wallkill Valley Railroad), a livery stable, two houses, a wagon shed, and two barns. Williams Lake, the best known of the Binnewater lakes, was home to the Williams Lake Resort, which included a hotel, a restaurant that was open to hotel guests and the public, and a private beach.

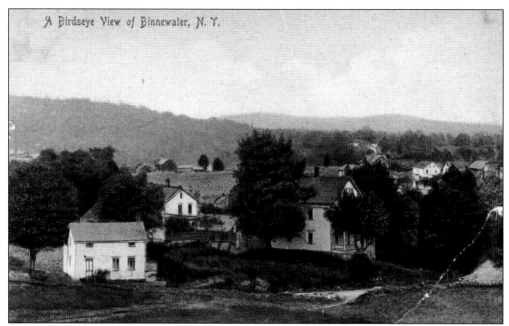

A BIRD'S-EYE VIEW OF BINNEWATER. The community of Binnewater is located south of the Fifth Lake and centered around a former Wallkill Valley Railroad Depot at the intersection of Breezy Hill Road and Ulster County Route 7. (GV.)

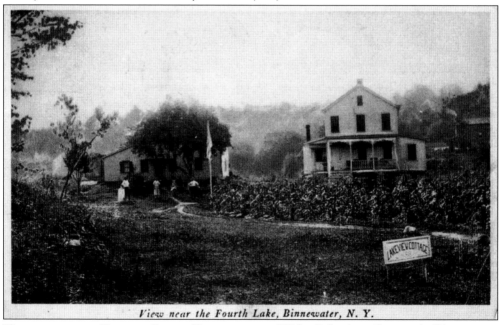

VIEW NEAR THE FOURTH LAKE, BINNEWATER, 1920s. Lakeview Cottage in Binnewater. By the 1920s, most of the inhabitants of Binnewater made their living farming. It was a hard life on rocky ground not particularly conducive to agriculture. Some residents lobbied for construction of a health resort in the hills around the Fourth Lake, which were reputed to have curative powers. Edwin Booth of Yonkers arrived there in 1913 with an incurable disease and returned home six weeks later hearty and hale. The card is postmarked April 4, 1926. (VW.)

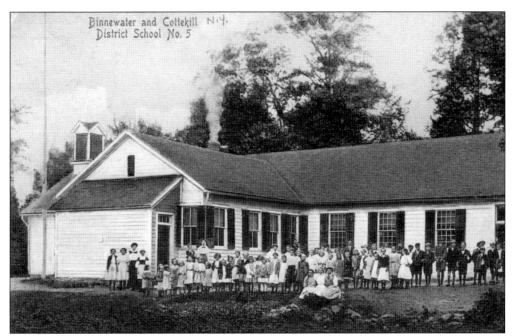

BINNEWATER AND COTTEKILL DISTRICT SCHOOL No. 5, EARLY 1900s. Schools like this served students living within four or five miles, which was considered close enough for them to walk. The school day started at 9:00 a.m. and went until 2:00 or 4:00 p.m. with one hour for lunch and recess. Students attended school for about four months of the year, depending on whether they were needed to help their family harvest crops. Less than 60 percent of school-age children attended school. This card is postmarked June 27, 1910. (VW.)

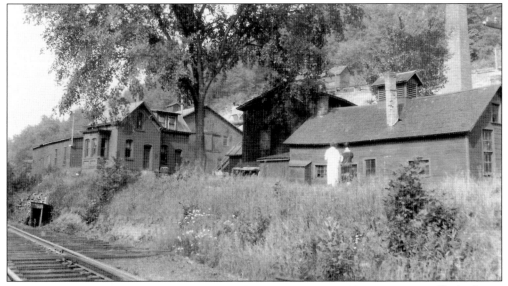

LAWRENCEVILLE CEMENT COMPANY AT BINNEWATER. By 1871, Lawrenceville had two cement factories and about 400 inhabitants. The Rosendale Cement Company's mills at Lawrenceville employed around 60 men and could manufacture approximately 350 barrels a day. Established by Watson E. Lawrence, the company was a pioneer in the manufacture of cement. (GV.)

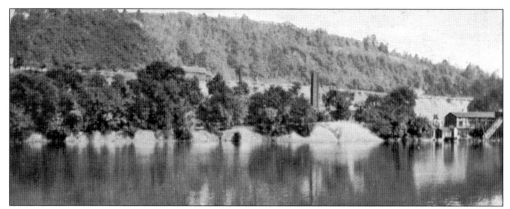

CEMENT MILLS AND MINES ON THE LAKE AT BINNEWATER, NEW YORK. The Lawrenceville Cement Company and F.O. Norton Cement Company had mills at Binnewater. In October 1891, a fire on the Wallkill Valley Railroad line destroyed the Lawrence Cement Company. The blaze, which resulted in $150,000 in damages, left some 225 men and boys temporarily unemployed. The cement company announced it would rebuild. The Norton cement mill at Binnewater shut down temporarily the following year because of falling prices due to the increasing availability of Portland cement. (CHHS.)

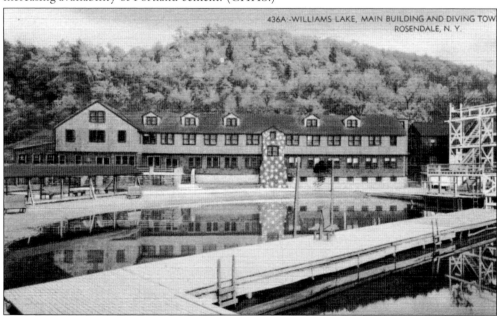

WILLIAMS LAKE, MAIN BUILDING. AND DIVING TOWER, ROSENDALE, NEW YORK. For more than 80 years, William's Lake was Binnewater and Rosendale's preeminent summer and winter destination. Gustav "Gus" Williams purchased the land in 1929. The resort had its grand opening on Sunday, May 5, 1929, advertising itself as "Gus. William's New Vacation Colony in the Heart of the Catskills" and "Nature's Paradise," with free holiday bathing and swimming on Williams Lake. By the 1930s, it was reputed to have the longest bar in New York State, with five bartender stations. Tragedy struck on July 28, 1953, when a fire ripped through the Williams Lake Hotel, killing four people and destroying two main buildings. Ten other guests were hospitalized. The hotel was rebuilt in 1954, expanding to accommodate and entertain guests year-round. The resort included a hotel, a restaurant that was open to hotel guests and the public, and a private beach club for members and hotel guests. (VW.)

ADVERTISEMENT FOR WILLIAMS LAKE.
Williams Lake offered something for
everyone. Water sports were especially
popular. The annual Williams Lake Canoe
Regatta, which was sponsored by the
American Canoe Association, began in
1936. The event attracted more than 100
competitors from New York City, Boston,
Washington, DC, and other east coast cities.
Thousands of spectators flocked to watch
the eight-hour program, which included
races, canoe jousting, and other canoe
events. (CHHS.)

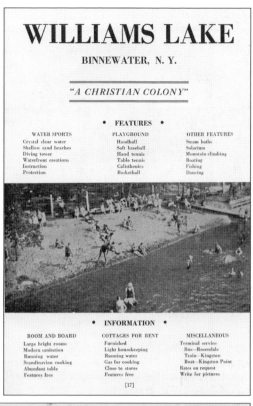

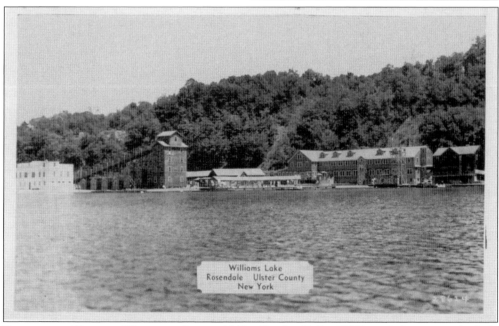

PANORAMA VIEW OF WILLIAMS LAKE, 1940s. By the 1940s, Williams Lake grew to include
Sunset Rest and Lakeshore House, cabins, the Toboggan Slide, a bathing beach, a hotel, a
diving tower, and a lodge. This card reads, "Weather is perfect. Plenty to eat and early to bed
is my routine. Leo." It is postmarked August 21, 1945. (GV.)

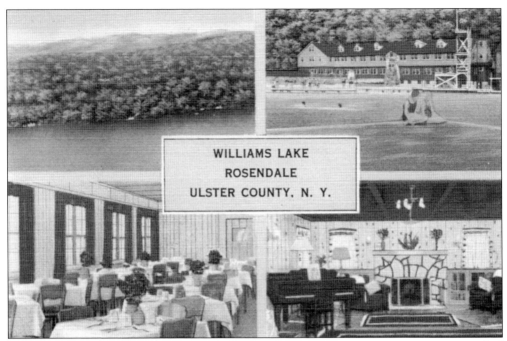

WILLIAMS LAKE, ROSENDALE, ULSTER COUNTY, NEW YORK. This linen card, postmarked June 28, 1951, advertises the resort as "one of the finest recreation and vacation centers in the Hudson Valley." The back of the card reads, "Hi Marie, Almost dinner time & everyone's knocked out from a softball game. Johnny's team won it. The married men against the single men. Only a couple more days—how we hate to go home. See you soon. Lois & Johnny." (VW.)

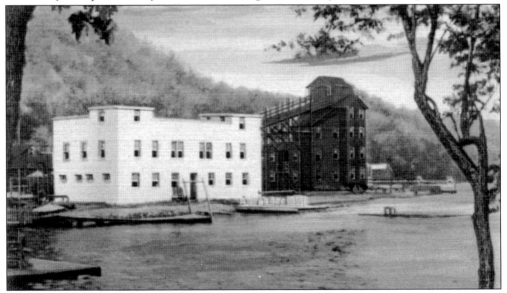

WILLIAMS LAKE, ROSENDALE, NEW YORK. This is a view of Sunset Rest, which featured Finnish steam baths and solariums, Lake Shore House and cabins with the Toboggan Slide. The only one of its kind in the Catskill region, the slide was completed in December 1940 before the first snowfall. It was five stories high and a thousand feet in length. Users achieved speeds of 60 mph, enjoying what was reported to be "the thrill of a lifetime on this new slide." (VW.)

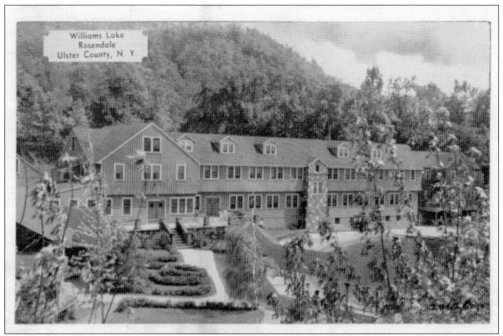

WILLIAMS LAKE, ROSENDALE, ULSTER COUNTY, NEW YORK. A view of the Williams Lake Hotel and Lodge in the early spring showing the shallow beach on the right and part of the lawn to the left. The card is postmarked 1950. (GV.)

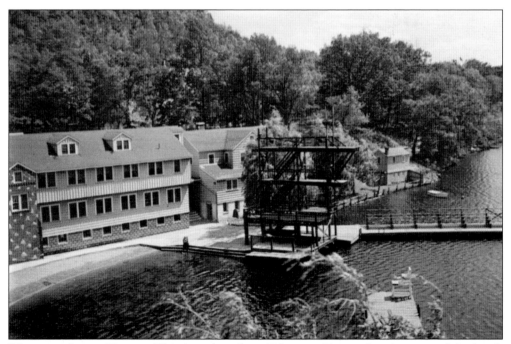

WILLIAMS LAKE HOTEL. This is a view from Toboggan Tower showing part of the hotel, lodge, and swimming and diving area. The card is marked 1950. (VW.)

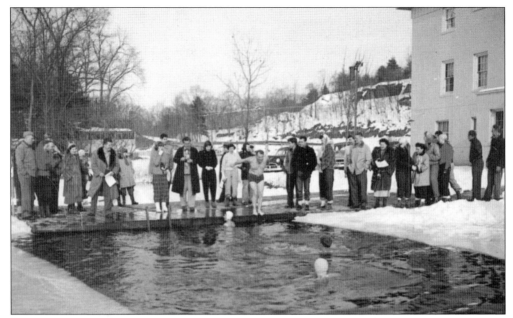

WILLIAMS LAKE HOTEL, ROSENDALE. The Williams Lake Polar Bear Club takes a dip in Williams Lake off the dock. The card reads: "Hi Folks. Having a wonderful time—food is terrific. Just finished our Turkey dinner. Newlyweds all over the place. Sorry to hear that Evelyn was sick. Hoping she is better. Send you Love, Marge & George." The card is postmarked November 1952. (VW.)

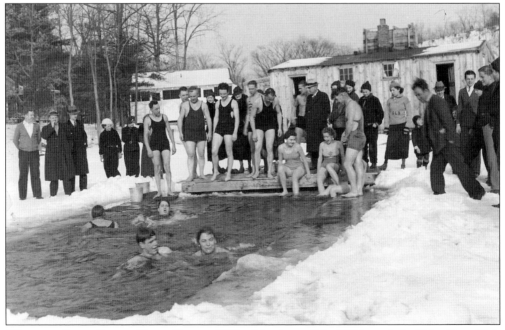

WILLIAMS LAKE POLAR BEAR CLUB, 1940S. Members of the Williams Lake Polar Bear Club prepare to take a plunge into the freezing waters of the lake—an annual Rosendale tradition dating back to the 1930s. In February 1939, more than two dozen individuals signed up for a dip in the icy waters. (CHHS.)

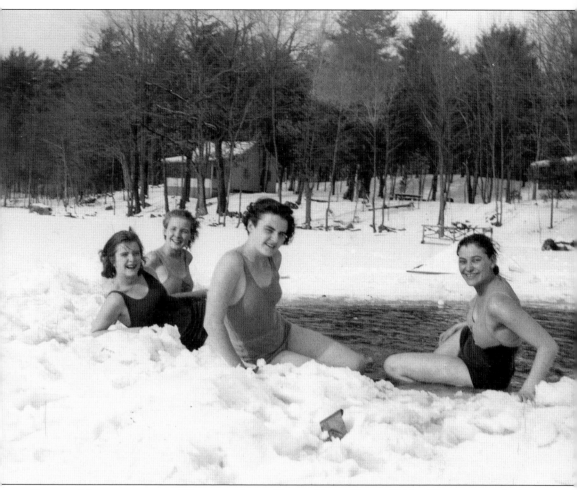

FEMALE MEMBERS OF THE WILLIAMS LAKE POLAR BEAR CLUB, 1940s. These women look surprisingly happy lounging in the snow by frozen Williams Lake. Films taken by newsreel men were shown all over the United States and abroad, especially in Germany, bringing fame and glory to Rosendale. (CHHS.)

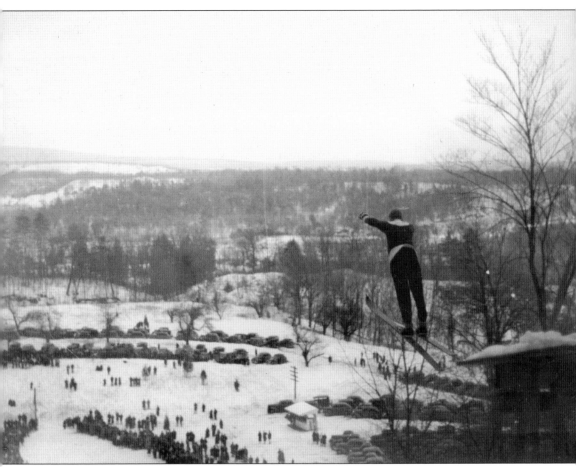

WILLIAMS LAKE SKI JUMP. Prior to and during the 1930s, most people associated ski jumping with the Hudson Valley, where events attracted thousands of spectators. A ski jump was built at the foot of Joppenbergh Mountain near Rosendale, which was used in both the winter and summer. On July 23, 1937, Kyrre Tokle of the Norway Ski Club won the 90-foot ski jump on the first-ever borax jump held in the eastern United States. Straw and pine needles had been used for previous mid-summer jumps. (CHHS.)

Seven

BLOOMINGTON AND COTTEKILL

Bloomington is a small hamlet southeast of Whiteport and between Rosendale and Eddyville. Originally called Bloomingdaal, it is one of the oldest settlements in the town of Rosendale. The old stone Le Fever House bears witness to the town's earliest days by the word "Bloomingdaal" carved over its lintel. Bloomington used to be part of southern Kingston and eastern Hurley. The beginning of religious worship in Rosendale began at Bloomington in 1796 or 1797 with the establishment of the church there. Prior to that time, devout inhabitants experienced great difficulty in attending worship services due to the distance involved in traveling to Kingston.

Greetings from Bloomington, N. Y.

46257

Bloomington Church

GREETINGS FROM BLOOMINGTON, NEW YORK, LATE 1930S. This scene is near where Creek Locks Road parallels Rondout Creek. Communities like Bloomington made the most of their beautiful natural setting to attract visitors. The message on the card reads, "Dear Aunt Dora, We like it here very much and have a lot of fun. The weather is fine and we are going boating and swimming. We send you our greetings from our vacation with many kisses to you." (GV.)

BLOOMINGTON CHURCH, PRE-1905. Bloomington's first house of worship was erected in 1797. It was destroyed by fire on December 28, 1846, and rebuilt in 1847. The elders of the church were a who's who of Rosendale's preeminent citizens, including William Dewitt, Johannes Du Bois, Jonathan LeFevre, John Freer, John Hardenbergh, John Keator, Cornelius Krom, Cornelius Sammons, and Jacob A. Snyder. The establishment of its own church was the hamlet's first step to separating from Kingston and, later, becoming part of Rosendale. (GV.)

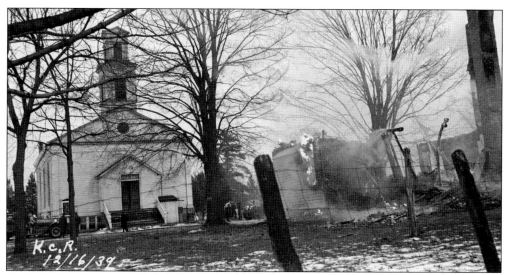

THE BLOOMINGTON CHURCH, 1939. Fires were an ever-present danger in the 18th and early 19th centuries due to the prevalence of wooden structures and open flames and the many deficiencies of early firefighting services. This photograph was taken immediately after a fire had destroyed most of the buildings around the church. Notice the fire truck parked in the front. (CHHS.)

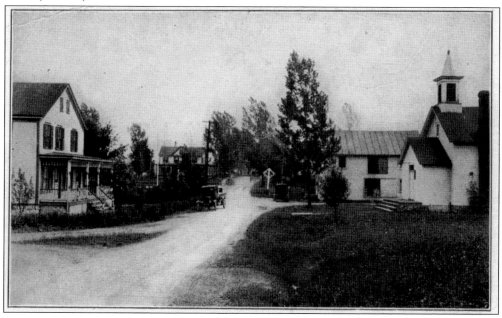

LOOKING EAST ON MAIN STREET, 1920s. This view looks east on Route 26 (Cottekill Road). Cottekill (meaning "Cats Creek") is a hamlet located two miles northwest of Rosendale. Founded by the Snyder family before the Revolutionary War, it expanded in the late 1800s from its agricultural origins, developing into a residential settlement of considerable importance. Many of its inhabitants worked at the nearby cement plants in Binnewater and Lawrenceville. Its public schools served Binnewater and upper Lawrenceville. Rosendale was its chief trading center until the building of the Ontario & Western Railroad branch through that locality in 1892. Socially, it maintained a close relationship with Rosendale. (VW.)

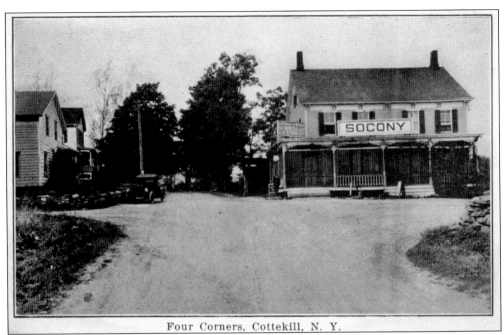

Four Corners, Cottekill, N. Y.

Four Corners, Cottekill, Early 1920. Cottekill's four corners, at the intersection of County Road 26 and Lucas Avenue, have changed little since this picture was taken in 1920. The large house on the right was a general store and SOCONY Vacuum Oil Company station. Following the break-up of Standard Oil in 1911, the Standard Oil Company of New York, or SOCONY, was founded, along with 33 other successor companies. In 1920, the company registered the name Mobiloil as a trademark. (GV.)

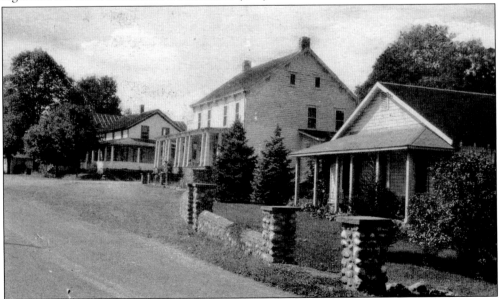

Greetings from Four Corners Inn, Cottekill. This is another view of the four corners later in the 1920s. The large building on the right was a general store and then the 4 Corners Deli for many years. Today, it is a catering business. This card is postmarked December 3, 1921. (VW.)

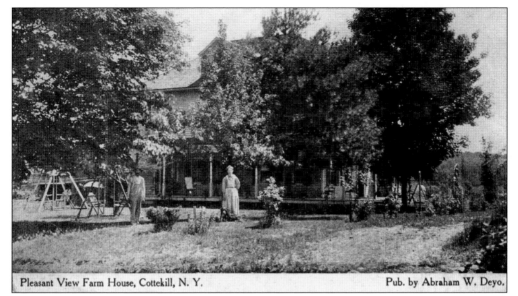

Pleasant View Farm House, Cottekill, N. Y. Pub. by Abraham W. Deyo.

PLEASANT VIEW FARMHOUSE, 1914. Pictured is a typical farmhouse in the Rosendale area. Some 30 million Americans still lived on farms in the early 1900s, a prosperous time for most farmers. The rapid expansion of farms, coupled with the diffusion of trucks and Model T cars and the tractor, allowed the agricultural market to expand to an unprecedented size. Some farmers, however, discovered it was more lucrative to transform their farmhouse into a boardinghouse. Pleasant View Farmhouse later became Mountain View House and Echo Lodge. (CHHS.)

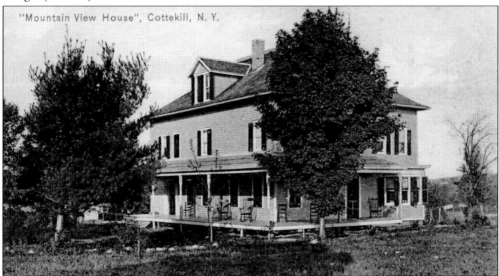

"Mountain View House", Cottekill, N. Y.

MOUNTAIN VIEW HOUSE. Built in 1907, A.W. Deyo's Mountain View House, later, Echo Lodge, could accommodate 30 guests. A 1914 brochure advertised the many attractions. Its spacious sleeping rooms with large windows afforded plenty of light and air. All rooms were neatly furnished with good beds. The house was bordered on two sides by a wide veranda, and a spacious, well-shaded lawn surrounded the house. There was a natural park several acres in size a short distance from the lodge. Guests could stroll or find a secluded spot in the cool shade of the pines, hemlocks, and maples. (GV.)

101

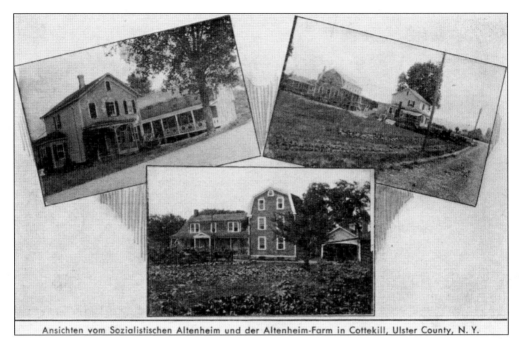

Ansichten vom Sozialistischen Altenheim und der Altenheim-Farm in Cottekill, Ulster County, N. Y.

THE SOCIALIST RELIEF SOCIETY, COTTEKILL. The Socialist Relief Society (SRS) was active in New York State beginning in the late 1920s. It sought to assist needy workers and their families. Some of its locations, like this one in Cottekill, were a combination of public restaurant and retirement home for Union Bakers from New York City. When it opened, in October 1939, more than 250 people attended. The building, which was equipped with the most modern equipment and furnishings, had 18 guest rooms, 4 washrooms, and a bath on each floor. This was the 10th building built by the SRS in Cottekill. (VW.)

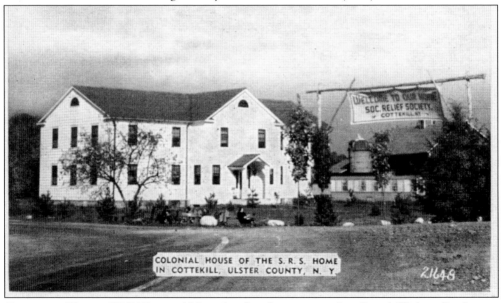

COLONIAL HOUSE OF THE S. R. S. HOME
IN COTTEKILL, ULSTER COUNTY, N. Y.

COLONIAL HOUSE SRS HOME. Although a farming community, Cottekill's boardinghouses attracted visitors from New York City during the summer. The back of the card reads, "Having a good rest in Cottekill. Weather is very nice. Greetings." (GV.)

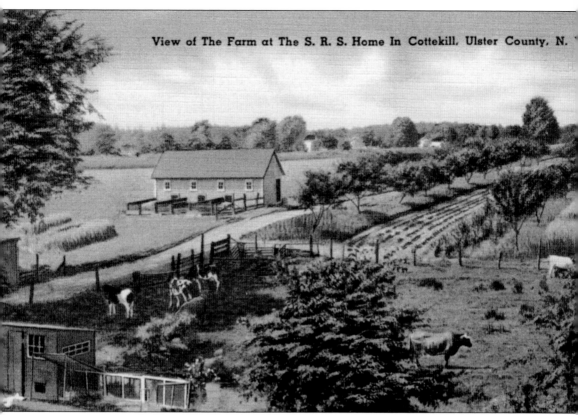

View of The Farm at The S. R. S. Home In Cottekill, Ulster County, N.

VIEW OF THE FARM AT SRS HOME. This SRS home was beautifully situated in the Catskill Mountains 900 feet above sea level. It advertised "Reasonable rates" and "All modern conveniences" along with "Products from our own farm." Its popular Bock Wurst parties and roast pork dinners on Saturday evenings were open to the public and well advertised in the *Rosendale News*. This postcard is dated August 6, 1941. (VW.)

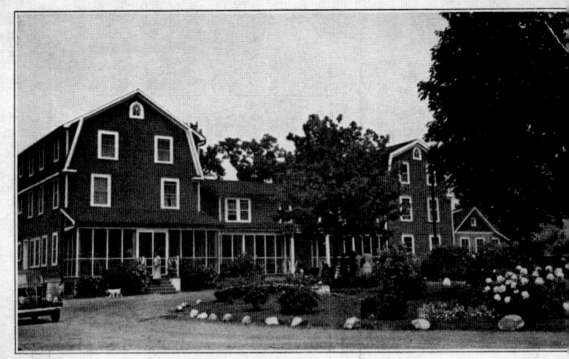

HOME FOR THE AGED, COTTEKILL, N. Y., ULSTER COUNTY

HOME FOR THE AGED, C. 1910. Small towns and communities throughout New York State were responsible for the care of their own. This building is a fine example of the resources even a small hamlet like Cottekill was capable of mustering in support of its elderly. The Cottekill Home for the Aged was known for its German fests, which served roast pork, homemade baloney, sauerkraut, and plenty of beer. Such events were advertised prominently in the *Rosendale News* in the 1930s and 1940s. (VW.)

Eight

CREEK LOCKS
AND HIGH FALLS

A hamlet of Rosendale on the eastern part of town, Creek Locks is located south of Bloomington and on the west bank of Rondout Creek, where the Delaware & Hudson Canal "locks" (flows) into the creek in the middle of town. The D&H Canal then paralleled Rondout Creek closely southward. Creek Locks was called "Wagondale" in pre–Revolutionary War days. The name changed to Creek Locks when the canal was constructed. Some of the original stone houses of old Wagondale are still occupied. By the mid-1870s, Creek Locks had two stores, a grocery, a school, a storehouse, and more than two dozen residences.

GREETINGS FROM CREEK LOCKS, N.Y.

GREETINGS FROM CREEK LOCKS. This is another idyllic view, looking south, with the Rondout on the left and Route 213 on the right. Route 213 followed the Rondout closely from the middle of town, southward. Creek Locks was home to several of Rosendale's captains of industry, including George W. LeFever, Abraham D. van Wagenen, Thomas McEvoy, and Elisha M. Brigham. (GV.)

OLD HOUSE AT CREEK LOCKS. New York's Hudson Valley contains some of the oldest examples of historic architecture in the eastern United States. It is best known for its Dutch houses built in the 17th and 18th centuries. The typical 18th-century stone house with its long, low facade, with multiple entrances and vague symmetry, evolved from the 17th century Dutch prototype house that had its front on a gabled end in the urban tradition. These houses were introduced to the New World when the Dutch West India Company began building trading settlements in New Amsterdam (New York City), Beverwyck (Albany), and, later, Wiltwyck (Kingston). Built in 1699, this house is one of the original stone houses of Wagondale. (RL.)

1410. Fishing at Creek LOCKS, N. Y.

FISHING AT CREEK LOCKS, NEW YORK. Creek Locks was another favorite spot for fishing, sightseeing, and relaxing. The areas streams and lakes were stocked with fish. This card is postmarked July 7, 1911. (VW.)

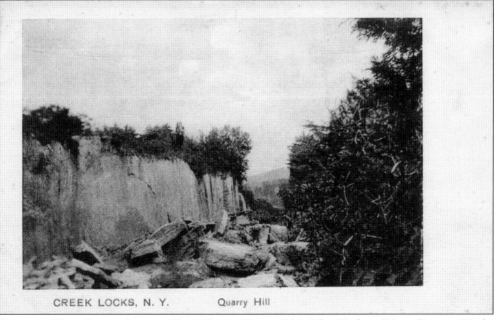

CREEK LOCKS, N. Y. Quarry Hill

QUARRY HILL CREEK LOCKS, NEW YORK, POST-1905. The Hudson River Cement Works had an extensive quarry near Creek Locks, employing 50 men. The stone was conveyed from the quarry on an inclined plane railway, the descending cars drawing up the ascending ones. The Warner Lime and Cement Company of Troy had a quarry and kilns in this town, employing 15 men. This card is postmarked May 11, 1911. (GV.)

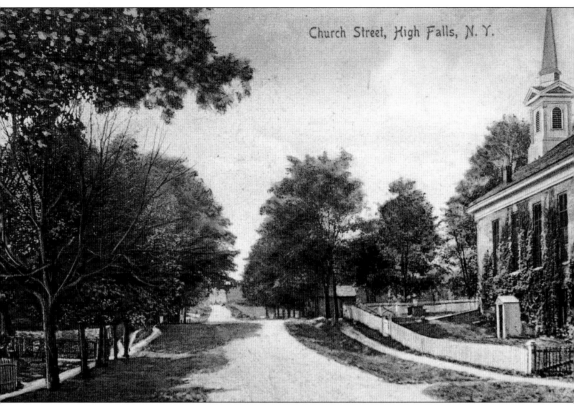

Church Street, High Falls, N. Y.

CHURCH STREET, EARLY 1900S. A hamlet in the southwest part of the Rosendale, High Falls was home to the Norton Cement Company and five locks of the D&H Canal. It takes its name from the nearby feature on the Rondout, where the creek cuts through a large rock formation and goes over a high waterfall. From colonial times, this attractive source of water power drew millers and businessmen into the area. The first bridge to nearby Stone Ridge, on the main road through the valley between the Shawangunks and Catskills, was built during this time. In the early 19th century, a cotton and wool factory made it a center of local manufacturing, serving many of the farms in the surrounding region. This set the stage for the construction and opening of the canal in 1828. High Falls was important not only for its location at a key water crossing but also for the natural cement discovered there during the canal's construction. The canal transformed the hamlet from an isolated rural community to a bustling, industrial town, especially after the D&H was expanded in 1850 to handle bigger barges. In addition to the facilities built by the Delaware & Hudson Canal Company, such as a lock tender's house and general store, small shops were built nearby to take advantage of the canal traffic. These buildings and the hamlet's street and block layout still exist today as a testament to that period. Development declined along with the canal's fortunes. The district has changed little since the canal ceased operations in 1899. (GV.)

DUTCH REFORMED CHURCH. This was the first house of worship in High Falls. The Dutch Reformed Church was the largest Christian denomination in the Netherlands. When the Dutch came to America in 1628, they brought their church with them. Worship initially centered around Kingston, but as local populations grew large enough, they began to build their own churches. This card is postmarked August 6, 1927. (GV.)

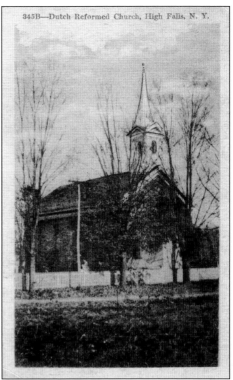

MOSSY BROOK FARM. Mossy Brook was located southeast of the center of High Falls. In 1940, America had almost 31 million farmers making up nearly 20 percent of the national workforce. New York State had more than 150,000 farms, the majority over 100 acres, covering more than half of the state's land area. Small farms, like the one in this postcard, grew vegetables, berries, stone fruits, and sunflowers. This card is postmarked May 16, 1941. (GV.)

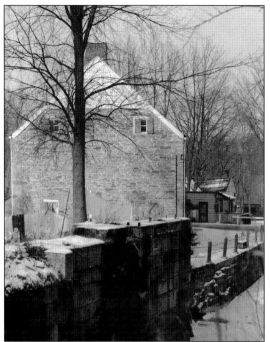

Depuy Canal House. Built in 1797, this became Simeon Depuy's Stone House Tavern in 1806. The inn profited from the opening of the D&H Canal in 1828. Initially, the canal ran to the west of the building. A rerouting in 1847 brought the canal and new Lock 16 within steps of the east front. Business flourished as DePuy catered to the hungry and thirsty "cannalers." The fortunes of the Stone House Tavern declined with the canal. In 1969, the inn was restored and opened as the Depuy Canal House. Receiving four stars from celebrated food critic Craig Claibourne, it became one of the Hudson Valley's premier culinary destinations until it closed in 2011. The Depuy Canal House will be reborn as the D&H Canal Museum. (GV.)

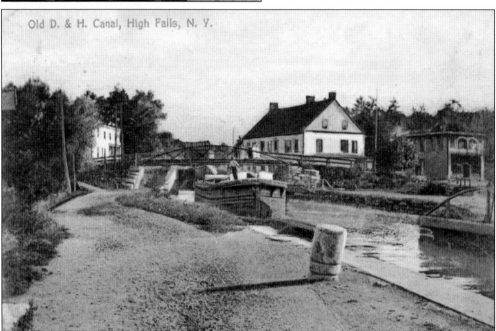

Old D&H Canal, High Falls, New York. The Deputy Canal House is visible center right, the High Falls canal bridge, in the center. A canal boat waits next to the towpath. Note the snubbing post in the foreground. A line would be thrown around it to secure a canal boat. Unlike many other canals of that era, the D&H Canal remained a profitable private operation for most of its existence. In the 1860s, its stock was valued at more than $200 a share. On July 13, 1825, the D&H Canal Company made history when it became the first million-dollar corporation in America. This card is postmarked June 18, 1908. (GV.)

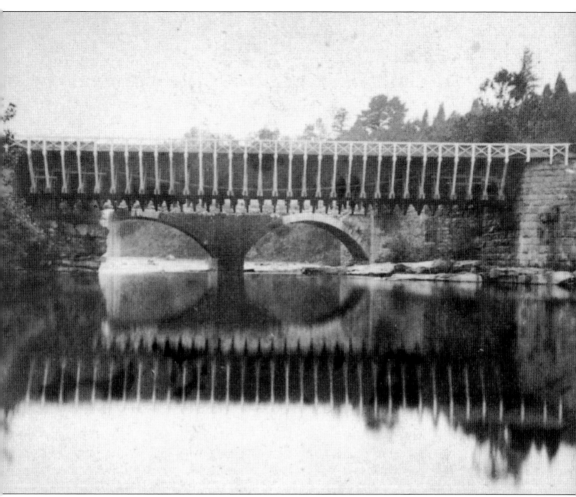

STEREOSCOPIC CARD OF THE AQUEDUCT AT HIGH FALLS. Constructed in 1850, the D&H Canal's suspension aqueduct over the Rondout Creek was designed by engineer John Augustus Roebling. It was one of four suspension aqueducts built on the D&H Canal by Roebling, who later gained fame as the designer of the Brooklyn Bridge. The structure was destroyed by fire in 1917 long after the canal was closed and abandoned. (NYPLDC.)

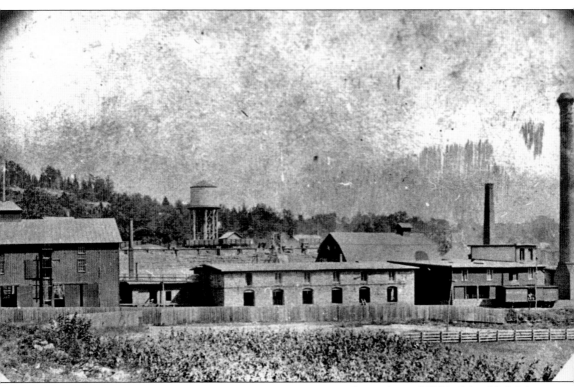

F.O. NORTON CEMENT WORKS AT HIGH FALLS. In the spring of 1826, John Littlejohn began quarrying, burning, and grinding limestone to produce cement for the construction of the D&H Canal. The first kiln was near the sulfur spring below High Falls. Later, Isaac L. Hasbrouck established a mill at High Falls. This was subsequently owned and operated by F.O. Norton in the latter part of the 19th century. By the beginning of the Civil War in 1861, three cement mills were operating in High Falls. (CHHS.)

Nine

LAWRENCEVILLE AND LEFEVER FALLS

Named in honor of Watson E. Lawrence, who opened a cement factory here in 1830, Lawrenceville is situated on Rondout Creek about a mile west of Rosendale. It was home to two cement factories and 400 inhabitants in the late 1800s. The average cement worker at this time toiled for 12 to 16 hours a day with low wages. Most worked 70 hours a week. Under constant threat of cave-ins and natural gas leaks, miners faced death and injury daily by explosions or machinery. Constant exposure to quartz, cement, and dust contributed to chronic bronchitis, asthma, silicosis, and other respiratory diseases, undermining the health and life expectancy of most mine workers.

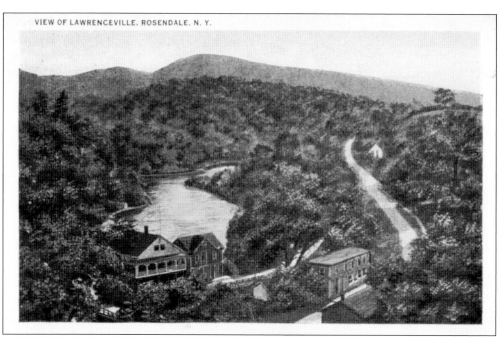

VIEW OF LAWRENCEVILLE, ROSENDALE, NEW YORK, EARLY 1900S. This postcard shows Lawrenceville from either the north end of the Wallkill Rail Road Bridge or Joppenbergh Mountain. The Rondout is clearly visible, as is Lawrenceville Road (State Route 213). The D&H Canal is masked by the trees. (GV.)

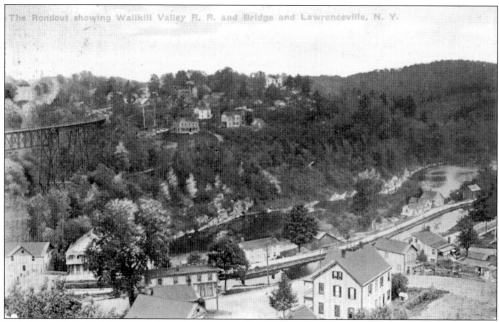

A POSTCARD OF THE RONDOUT. The D&H Canal is visible to the right of the Rondout. The Wallkill Valley Rail Road Bridge and Joppenbergh Mountain are visible left and center. The card is postmarked 1913. (VW.)

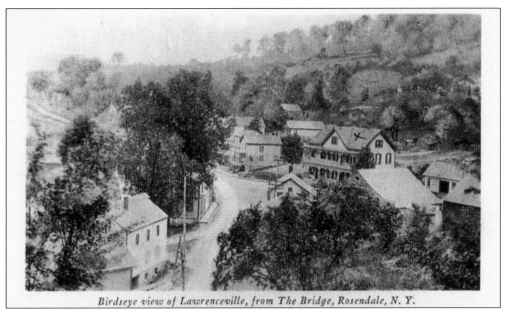

Birdseye view of Lawrenceville, from The Bridge, Rosendale, N. Y.

BIRD'S-EYE VIEW OF LAWRENCEVILLE FROM THE BRIDGE, EARLY 1900S. This photograph shows Lawrenceville Road (State Route 213) running through town. The building with the "X" on it is Zeigler's Mountain House, which is no longer in existence. (GV.)

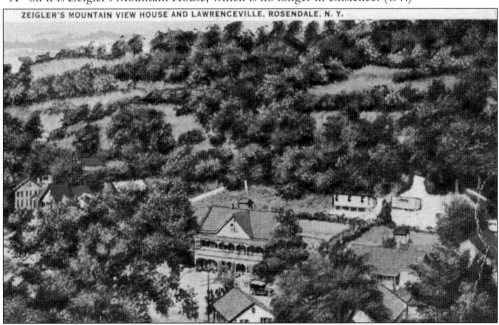

ZEIGLER'S MOUNTAIN VIEW HOUSE AND LAWRENCEVILLE, 1920S. Rudolph Zeigler was the proprietor of Lawrenceville's most popular boardinghouse and hotel, which advertised "Large Airy Rooms" with modern improvements like "Hot and Cold Running Water" and "German-American Cooking." Mountain View House was also a small farm, which grew vegetables and raised chickens and ducks. It was open year-round, could accommodate 50 guests, and was conveniently located close to churches, stores, and amusements, with bathing and fishing nearby. Gentiles were welcome. Rates were $3 a day or $16 a week. (RL.)

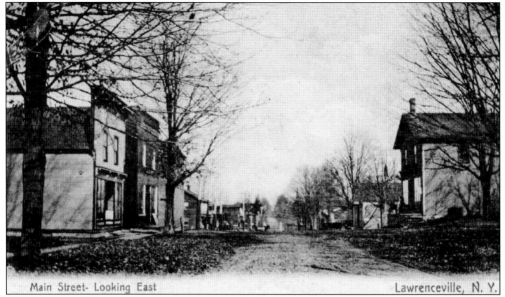

Main Street- Looking East Lawrenceville, N. Y.

LOOKING EAST ON MAIN STREET, POST-1905. This view of Main Street in Rosendale, from the late 1800s or early 1900s, looks from the Lawrenceville side of the town eastward. The photograph has been reversed. The buildings on the right should be on the left and vice versa. Most of the buildings on the D&H Canal side of Main Street (the right side of the postcard) have since disappeared to be replaced by newer ones. When this photograph was taken, Lawrenceville had a population of some 300 people. This card is dated September 1, 1907. (GV.)

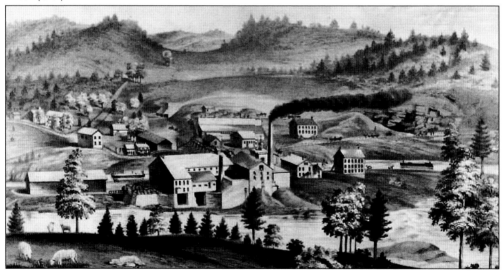

LAWRENCEVILLE CEMENT COMPANY WORKS, ROSENDALE, 1880. The cement works, which could produce up to 700 barrels of cement in a day, housed a 225-horsepower steam engine and were dominated by a tall smokestack. Although the Wallkill Valley Railroad had reached Rosendale by this time, the cement works were still dependent on roads and wagons to transport the cement from the nearby quarries to the kilns on the hillside above the mill, and on the D&H Canal to bring the coal for the kilns and carry out barrels of cement from the works. In 1854, the kilns were connected to the cement mill by a short, man-powered railway. (RL.)

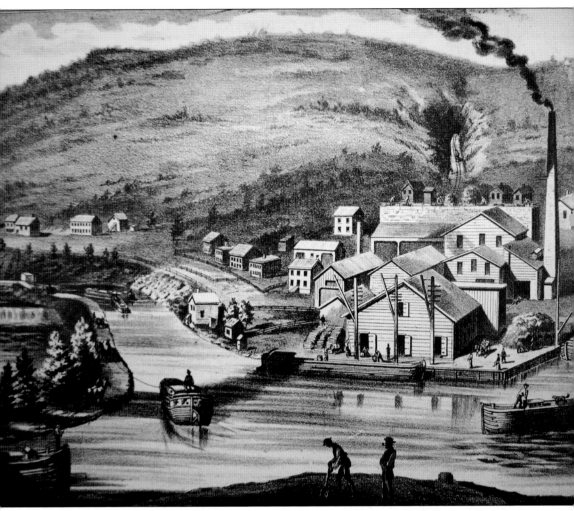

THE NEW YORK CEMENT COMPANY AT LEFEVER FALLS. The New York Cement Company at LeFevre Falls manufactured about 500 barrels of cement per day and about 100,000 barrels during the season. The Martin & Clearwater Cement Works was also located at LeFevre Falls. It had a capacity of 80,000 barrels per season, employing about a hundred men. Formerly known as Rock Lock, LeFever Falls had a store, three hotels, two cement factories and about thirty dwellings in the early 1870s. Located about a mile north of Rosendale on the high cliff above Rondout Creek, the water can be seen rushing over the rocks below. It was an early fording place used by George Washington's Continental Army. Across the river are ruins of a powder mill, which furnished gunpowder during the Civil War. (RL.)

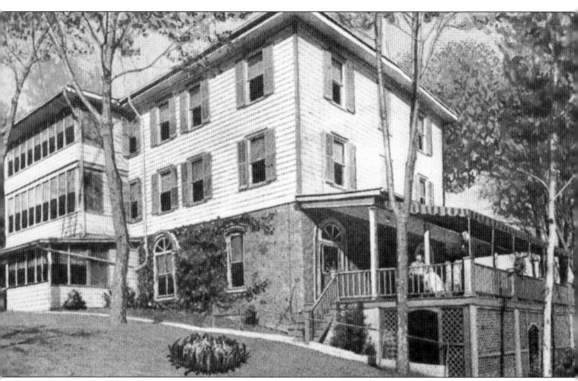

LANGE'S LEFEVER FALLS MANSION, ROSENDALE, NEW YORK. Otto Lange's LeFever Falls Mansion was advertised as "a modern summer resort with large, airy rooms, all having hot and cold water." A working farm, its excellent table was supervised by Mrs. Lange. For sports and entertainment, the mansion featured tennis, bowling, a private swimming pool, a handball court, a solarium, and dancing. (RL.)

Ten

An Enduring Legacy

Waterproof, hard, and enduring, Rosendale cement was used in the construction of many of New York's and America's most iconic structures. New York State engineers noticed that bridges and structures built with Portland cement were already deteriorating noticeably by the 1930s. Those built of Rosendale cement, even as far back as 100 to 150 years ago, were generally in better condition. Small quantities of Rosendale cement are still being produced, by Edison Coatings Incorporated in Plainville, Connecticut, to restore structures originally built with Rosendale cement and repair others in which the cement was not used in their original construction.

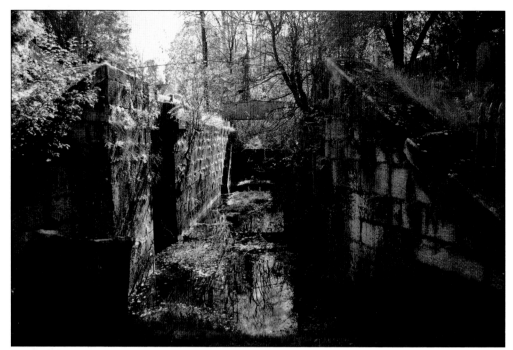

D&H CANAL TODAY. Massive amounts of Rosendale cement were used in the construction of the 108-mile canal and its 108 locks. Between 1828 and 1899, canal barges carried tremendous quantities of anthracite coal, which fueled America's Industrial Revolution and the Rosendale cement industry. From the coal mines of Pennsylvania and the cement mines of Rosendale and Ulster County to the Hudson River for further transportation, the canal fueled New York City's construction boom. The D&H Canal stimulated the growth of the Hudson Valley region in the 19th and 20th centuries, encouraging settlement in the sparsely populated area. (GV.)

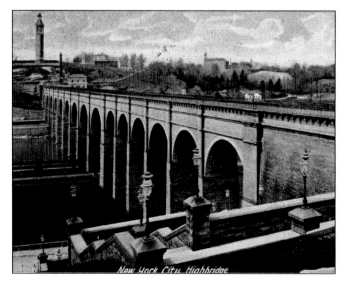

NEW YORK CITY, HIGH BRIDGE. High Bridge (originally the Aqueduct Bridge) is the oldest bridge in New York City. It originally opened as part of the Croton Aqueduct in 1848. Designed as a stone arch bridge, High Bridge had the appearance of a Roman aqueduct. In 1928, to improve navigation on the Harlem River, the five masonry arches that spanned the river were demolished and replaced with a single steel arch of about 450 feet. This card is postmarked September 19, 1907. (GV.)

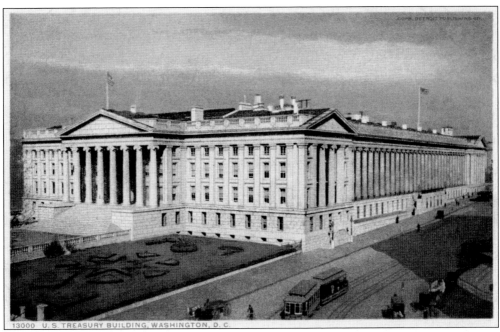

US Treasury Building, Early 1900s. The Treasury Building is the oldest departmental building in Washington. It was built over a period of more than 30 years, having suffered several fires. The Central Building and East Wing were constructed between 1836 and 1842. The South Wing was added between 1855 and 1861. The West Wing was erected between 1862 and 1864. The North Wing was raised between 1867 and 1869. The product of five different architects over the years, it was built in the Neoclassical style. This card is postmarked August 17, 1907. (GV.)

Washington Monument, Washington D. C.

J. F. Jarvis, 16 Penna. Ave., Wash., D. C.

Washington Monument, Early 1900s. Construction of the Washington Monument began in 1848. It was halted from 1854 to 1877 due to a lack of funds, a struggle for control over the Washington National Monument Society, and the intervention of the American Civil War. Although the stone structure was completed in 1884, internal ironwork and other finishing touches were not completed until 1888. The monument has undergone extensive restoration and repair since its construction. A total of 30 of the 194 memorial stones contributed by states, cities, foreign countries, and others are made of limestone. (GV.)

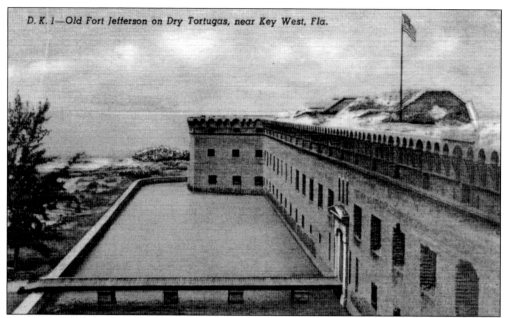

OLD FORT JEFFERSON ON DRY TORTUGAS, NEAR KEY WEST, FLORIDA, 1940. Located on Garden Key in the lower Florida Keys within the Dry Tortugas National Park, Fort Jefferson is a massive coastal fortress. Built in 1861 with Rosendale cement, it is the largest brick masonry structure in the Americas, covering 16 acres. The fort was operational during the Civil War (1861–1865). Afterward, it became a federal prison, known as America's Devil's Island. Dr. Samuel Mudd was imprisoned there for giving medical assistance to John Wilkes Booth, President Lincoln's assassin. Rosendale cement, from the Edison Coatings company, was used again to renovate the structure, replacing the mortar securing the structure's 16 million bricks. (GV.)

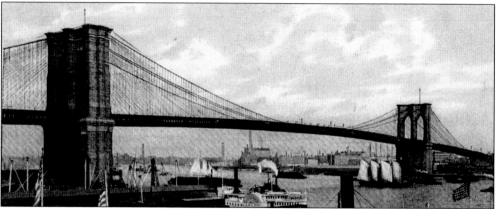

BROOKLYN BRIDGE, NEW YORK, EARLY 1900S. New York City's Brooklyn Bridge is one of the oldest roadway bridges in the United States. It spans the East River, connecting Manhattan and Brooklyn. Conceived by German immigrant John Augustus Roebling, construction started in 1869 and was completed in 1883. Originally called the New York and Brooklyn Bridge and the East River Bridge, it was later dubbed the Brooklyn Bridge. It is the longest suspension bridge of its era and, when built, was the highest freestanding structure of the Northern Hemisphere. The bridge cost $15.5 million in 1883 (about $400 million today). This card is postmarked April 18, 1909. (GV.)

STATUE OF LIBERTY, NEW YORK CITY. The 154-foot base or pedestal of the Statute of Liberty was completed in 1886, opening the way for the erection of the iron framework that supports the statues copper skin. Upon completion, the concrete pedestal was the largest building in the United States in the 19th century. Its construction required 27,000 tons of concrete and stones. It is said that the structure is so robust that any attempt to overturn the statue would tip the island. (GV.)

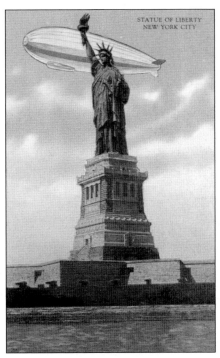

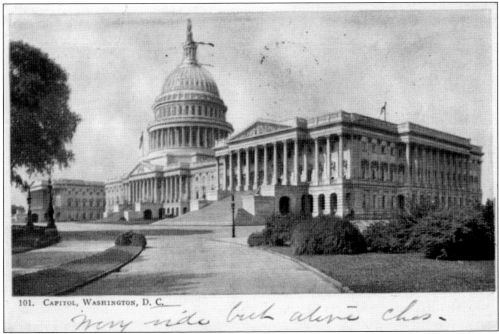

US CAPITOL. Originally built in 1800, the US Capitol is the work of 11 different architects. Pres. George Washington laid the cornerstone of the US Capitol in the building's southeast corner on September 18, 1793. Congress first met in the new building in November 1800. During the war of 1812 the British set fire to the Capitol. A rainstorm prevented its complete destruction. The East Portico was completed in 1828. The East Front was rebuilt in 1904. Major restoration took place from 1959 to 1960 and again from 2014 to 2017. (GV.)

GRAND CENTRAL TERMINAL STATION, NEW YORK CITY. Designed by John B. Snook and financed by Cornelius Vanderbilt, Grand Central Depot opened in October 1871, bringing trains of the New York Central & Hudson River Railroad, the New York & Harlem Railroad, and the New York & New Haven Railroad together in one location. The depot was demolished between 1903 and 1913 and replaced by the current Grand Central Terminal, the biggest terminal in the world at the time, both in the size of the building and in the number of tracks. It underwent a major renovation between 1993 and 2000. (GV.)

SPILLWAY AND BRIDGE, ASHOKAN RESERVOIR, CATSKILLS MOUNTAINS, NEW YORK. Located 14 miles west of Kingston, the Ashokan Reservoir in Ulster County was built between 1907 and 1915 and involved the construction of five and a half miles of dams and dikes within the Esopus Creek drainage. This 8,315-acre reservoir is the major component of the Catskill System of the New York City Water supply. Ashokan Bridge is 1,100 feet long. With an elevation of 590 feet above sea level, the capacity of the reservoir is 128 million gallons. The reservoir is 12 miles long and 3 miles wide. It has a shoreline of 40 miles with 10 concrete bridges. Construction of the main bridge cost $30 million. When completed, the entire system cost $177 million ($4.2 billion today). (GV.)

CROTON DAM OF THE NEW YORK RESERVOIR. This postcard depicts the second or New Croton Dam built between 1892 and 1906 near Croton-on-Hudson. The Croton Dam, Reservoir, and Aqueduct are another part of New York City's extensive water-supply system. The reservoir, in northern Westchester County, New York, was the city's first artificial source of water. The dam is 266 feet wide at its base and 297 feet high. The spillway is 1,000 feet across. At the time of its construction, it was the tallest dam in the world. The New Croton Dam provides New York City with 19 billion US gallons of water. (GV.)

NEW US SUPREME COURT BUILDING, WASHINGTON DC, 1930S. The cornerstone for the current four-story US Supreme Court Building was laid on October 13, 1932. Construction was completed in 1935. The building cost about $10 million (about $177 million today). Designed by architect Cass Gilbert as a great marble temple, it was planned on a scale in keeping with the importance and dignity of the court and the judiciary as a coequal, independent branch of the US government, and as a symbol of the national ideal of justice in the highest sphere of activity. This card is postmarked September 23, 1936. (GV.)

ROCKEFELLER CENTER, NEW YORK, 1930s.
Originally built of Rosendale cement, construction of the Rockefeller Center complex started in 1931. The first building opened in 1933. The core of the complex was completed by 1939. Rosendale cement from the Edison Coatings Company was used in the $75 million renovation of the observation roof atop the 70-story 30 Rockefeller Center. (GV.)

NEW YORK STATE THRUWAY AND THE CATSKILL MOUNTAINS, 1950s. Governor Thomas E. Dewey Thruway is the longest toll expressway in the world, comprising 570 miles of superhighway. The first section opened in 1954; the remainder was completed by the end of the decade. When it opened, it cost $1.34 million per mile, or more than $750 million (about $7 billion today). Some 55 million trips were made in its first year of operation. Ironically, construction of the Thruway killed tourism in Rosendale and Ulster County. New Yorkers could now travel hundreds of miles from the city on weekends and be back in time for work on Monday. (GV.)

BIBLIOGRAPHY

Beers, F.W. *County Atlas of Ulster New York*. New York: Walkers & Jewett, 1875.

Commemorative Biographical Record of Ulster County, New York, Containing Biographical Sketches of Prominent and Representative Citizens, and of Many of the Early Settled Families Illustrated. Chicago: J.H. Beers & Company, 1896.

Child, Hamilton. *Gazetteer and Business Directory of Ulster County N.Y. for 1871–1872*. Syracuse: 1871.

Clearwater, Alphonso T., ed., *The History of Ulster County New York*. Kingston, New York: W.J. Van Deusen, 1907.

Gordon, Thomas F. *Gazetteer of the State Of New York: Comprehending Its Colonial History: General Geography, Geology, and Internal Improvements*. Philadelphia: 1836.

Harbrouck, Kenneth E., ed. *History of Ulster County with Emphasis on the Last 100 Years*. Historians of Ulster County, 1983.

Huben Jr., Stephen E. *The Villagers*. Morrisville, NC: Lulu Publishing, 2007.

Knapp, Ronald G. and Michael Neil O'Donnell. *The Gunks (Shwanagunk Mountains) Ridge and Valley Towns Through Time*. Gloucestershire, England: Fonthill Media, 2015.

Lesley, Robert W. *History of the Portland Cement Industry in the United States*. Chicago: International Trade Press, 1924.

Mabee, Carleton, and John K. Jacobs. *Listen to the Whistle: An Anecdotal History of the Wallkill Valley Railroad in Ulster and Orange Counties, New York*. Fleischmanns, NY: Purple Mountain Press, 1995.

MacKenzie, Alan. "Historic House at Rosendale." The *Kingston Daily Freeman*. October 17, 1930.

Platt, Francis Marrion. *History of Binnewater in the Cement Mining Times*. Rosendale, NY: Women's Studio Workshop, 2003.

Rhoads, William B. *Ulster County New York. The Architectural History & Guide*. New York: Black Dome Press, 2011.

Sullivan, Catherine. *The Rosendale News. Featuring "Do You Remember?" Joseph Fleming*. Rosendale Library: Catherine Sullivan, 2015.

Sylvester, Nathaniel Bartlett. *History of Ulster County, New York: with illustrations and biographical sketches of its prominent men and pioneers*. Woodstock, NY: the Overlook Press, 1977.

Tantillo, Linda. *Months Pasts in the Rondout Valley*. Blue Stone Press, February 2008– March 2018.

DISCOVER THOUSANDS OF LOCAL HISTORY BOOKS FEATURING MILLIONS OF VINTAGE IMAGES

Arcadia Publishing, the leading local history publisher in the United States, is committed to making history accessible and meaningful through publishing books that celebrate and preserve the heritage of America's people and places.

Find more books like this at
www.arcadiapublishing.com

Search for your hometown history, your old stomping grounds, and even your favorite sports team.